CREATING A

# BRAND
# IDENTITY®

CREATING A

# BRAND IDENTITY®

**A GUIDE FOR DESIGNERS**

**CATHARINE SLADE-BROOKING**

LAURENCE KING PUBLISHING

**LAURENCE KING**

Published in Great Britain by

Laurence King Student & Professional
An imprint of Quercus Editions Ltd
Carmelite House
50 Victoria Embankment
London EC4Y 0DZ

An Hachette UK company

Reprinted in 2024

A CIP catalogue record for this book is available
from the British Library

TPB ISBN 978-1-78067-562-6

10 9 8

Design by Lizzie Ballantyne

Printed and bound in China by C&C Offset Printing Co., Ltd.

Special thanks to:

Richard and Elliott and to all my students – past, present and future.
This book is dedicated to them.

# CONTENTS

The desire to visualize an identity is not a modern phenomenon. These beautiful impressions left by our ancestors in the Cueva de las Manos (Cave of the Hands) in Argentina date back 13,000 years.

# INTRODUCTION

## Why should you read this book?

We are very fortunate that there is now a host of books covering branding from a wide range of perspectives, including advertising, design management, business and marketing. There are, however, only a few written from the designer's perspective and no others that explore the complex practical creative processes involved in creating a brand.

This book has therefore two main aims. The first is to introduce you to branding, a complex and fascinating area of visual communication that spans the practical skills and techniques of graphic design as well as aspects of social and cultural theory. The second is to provide you with the creative tools – both theoretical and practical – that will enable you to tackle designing your own brands, from researching the target consumer to considering the name, as well as how to apply the final brand identity.

## Who should read it?

The book is designed to appeal to anyone who aspires to or works in this fascinating area of design. You may be a degree-level student looking for guidance and inspiration or a lecturer sourcing course materials. This title will also benefit graduates and postgraduate students seeking insights into an industry that they are considering. Finally the book also aims to appeal to design practitioners needing a refresher and companies embarking on commissioning a brand for the very first time.

Branding is a global phenomenon, with the growth of the discipline particularly evident in developing nations. For these emerging economic powers the importance of branding in helping to secure new markets for their products both at home and internationally is clearly understood. Therefore the book also aims to encompass issues of cultural design, with the intention of developing a wider international readership.

## What will you learn?

The book is divided into two key sections. The first places branding into a theoretical and historical context, highlighting how and why we brand and branding strategies. Focusing on key theories related to consumerism, it explores issues of brand identity, why we buy and how branding is changing in the twenty-first century. You will also be introduced to the anatomy of branding, helping you to gain an understanding of the vocabulary and terminology used in the industry. Finally you will develop an appreciation of the strategies used by designers to create successful brands, including the application of semiotics to enhance meaning and how to identify unique selling points to ensure successful sales.

The second section of the book introduces you to the practical branding design process used by industry to create a brand. It highlights key activities undertaken by designers to 'manage' the creation of a successful brand identity and to ensure that they stick effectively to the client's original brief. You will learn how the design process works by exploring the 'step-by-step' methodology used by design agencies to research, define an audience, create a unique name and logo and test a new identity.

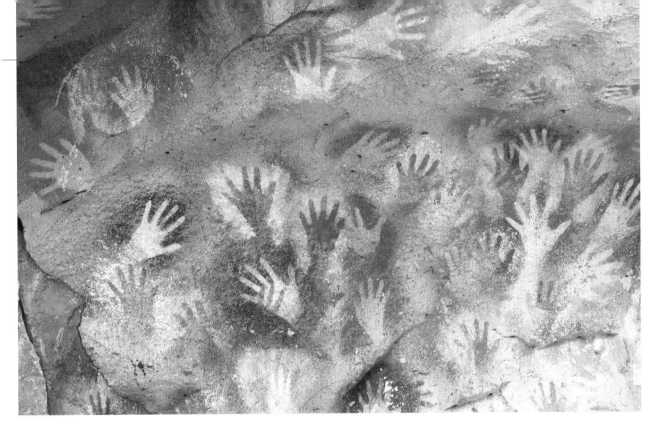

## How is the book designed?

As designers we are primarily visual animals, so the book uses images throughout to illustrate the text, including examples of professional design concepts, brand case studies and diagrams. Flow-charts are also used extensively to highlight the step-by-step methodology applied by industry professionals to create a brand. Other examples of how to undertake practical design processes, such as the creation of consumer and mood boards, are explored through creative exercises. 'Tips & tricks' sections give guidance on how to undertake a variety of creative assignments.

## What was the inspiration for the book?

The content of this book has been derived from two main sources. The first was experience of entering the world of branding as a graduate and having to learn the hard way, 'on the job'. The years of creating brands for both small independent start-up businesses and multinational corporations has in turn enabled me to develop teaching materials for undergraduate and postgraduate students on the Graphic Communication course at the University of the Creative Arts.

Many of the diagrams, exercises and flow charts you will see in the book have been developed through my own creative practice and tested by my students. It is my alumni that I have to thank for many of the other images within this publication. With careers ranging from Junior Designers to Creative Directors and from Studio to Account Managers, they have provided me with an invaluable resource of information on current industry practice. They have been generous in not only offering examples of their own work, but also personal insights into their own creative practice, for which I am exceptionally grateful.

Finally I hope that this book will not only help to serve as a resource and support for teaching, offering a window into this fascinating area of graphic design, but will also inspire and guide those whose ambitions are to enter it.

Celebrity branding has become ubiquitous in our modern consumer society. The creation of a unique identity enables stars to promote not only themselves but also a whole range of consumer products.

# CHAPTER 1: BRANDING BASICS

Brands have become an integral part of modern consumer society. They are used to promote everything from jeans to the British Royal Family. However, arriving at a satisfactory definition of a 'brand' is far from simple.

A brand is much more than a product you buy. Brands are as relevant to businesses as to services, and they can be applied to ideas and concepts as well as to products – a brand can even represent an individual celebrity. To be able to define what a brand is and does in its simplest form, it is helpful to consider first why people buy, and what influences their choice of one product over another.

## CONSUMER CULTURE – WHY DO WE BUY?

What we buy is determined not just by our basic needs, but also by what our chosen brands say about us. Brands therefore position themselves to become integral to consumers' lifestyles, whatever their social aspirations.

Being a consumer is about identifying one's needs and satisfying them by choosing, buying and using a product or service. These needs can be as varied as comsumers themselves, although there are basic requirements that are fundamental for all humans, namely food, clothes and shelter.

These basic necessities are then followed by more subjective needs, defined by a person's particular lifestyle, which is, in turn, predetermined by their culture, society, social group and class.

These purchases are often driven by more than basic need, as aspirations and desires also influence what people choose to buy. Social pressures can play an important role in this, as the need to fit in, or appear more successful than those around us, can be highly influential in our buying decisions.

Understanding why people buy and the triggers that make them choose one item over another is key to designing appropriately and successfully for today's brand-savvy consumer.

*'Women usually love what they buy,*
*yet hate two-thirds of what is in their closets.'*

Mignon McLaughlin, American journalist and author (1913–1983)

Whether it's a second-hand VW campervan or a Mini Cooper, the car you drive is an obvious indicator of both your personality and lifestyle.

## What is Consumerism?

The *Oxford English Dictionary* first featured the word 'consumerism' in its 1960 edition, defining it as an 'emphasis on or preoccupation with the acquisition of consumer goods'. However, more modern critical theory often describes it in relation to the tendency of an individual to define themselves in relation to the products and services they buy or consume. This trend is most evident in the perceived status of owning certain luxury goods, such as cars, clothing or jewellery, with some people willing to pay a premium to own a product that has been made by a particular brand.[1] Consumer culture theory argues that people buy one brand over another because they feel it reflects their own personal identity, or one that they wish to create.[2]

In her book *Consumer Culture*, Celia Lury explores the way an individual's position in social groups – structured by class, gender, race and age – affects the nature of his or her participation in consumer culture. She highlights the powerful role consumption plays in our lives, and how our highly sophisticated modern consumer culture provides new ways of creating personal, social and political identities. One of the conclusions she reaches has a direct relationship to the role played by design; she argues that as consumer culture has become increasingly stylized, it has come to provide an important context for everyday creativity.

1   The above explanation for self-branding summarizes M. Joseph Sirgy's self-congruity theory – *Self-congruity: Toward a Theory of Personality and Cybernetics* (Greenwood Press, 1986).

2   For more on consumer culture theory see Don Slater, *Consumer Culture and Modernity* (Polity Press, 1997).

*'Products are created in a factory.*
*Brands are created in the mind.'*

*Walter Landor, designer and branding/consumer-*
*research pioneer (1913–1995)*

# WHAT IS A BRAND?

The practice of branding is far from new. Early man began the custom of leaving a mark on objects to signify ownership of property, to reflect a person's membership of a group or clan, or to identify political or religious power. The pharaohs of ancient Egypt left their signature in the form of hieroglyphs all over their temples, tombs and monuments. The ancient Norse branded their animals with hot irons – a practice continued today by American cowboys, amongst others. However, the term 'brand' in its contemporary sense is relatively new, being principally the attachment of a name and reputation to something or someone, primarily to distinguish it from the competition.

A brand is also far more than the name, logo, symbol or trademark that highlights its origin; it is imbued with a set of unique values that defines its character and works as an unwritten contract, promising to deliver satisfaction by providing consistent quality each time it is bought, used or experienced. Brands also seek to connect emotionally with their consumers, to ensure that they are always the first and only choice, creating lifelong relationships.

The whole brand creation process – its design and marketing – has consequently become vital to the success of any new product, service or venture. Indeed, in the twenty-first century the manipulation and control of a brand's image has become, in many cases, more important than the 'real' thing the brand represents, with the design of the product now often acting as a vehicle for the brand's values. Rather than a brand existing to sell more of a particular product, products are now developed to extend and reinforce a brand success, and the 'image makers' – designers, ad agencies and brand managers – have become central to our modern consumer culture.

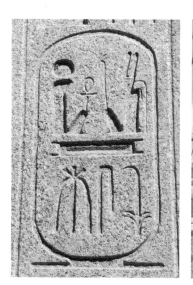

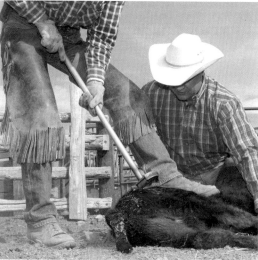

**Far left:** Marking systems have always been important conveyors of information, especially in societies with restricted literacy. In ancient Egypt, carved oval cartouches were used to indicate a royal name.

**Left:** Branding is said to have started in Sweden during the Middle Ages. A brand in this context was the action of burning a symbol into the flesh of an animal in order to signify ownership.

**Opposite:** It might be argued that branding has changed very little in the last 3,000 years. Gabrielle 'Coco' Chanel's iconic 'cartouche' logo has made her name immortal in the world of high fashion.

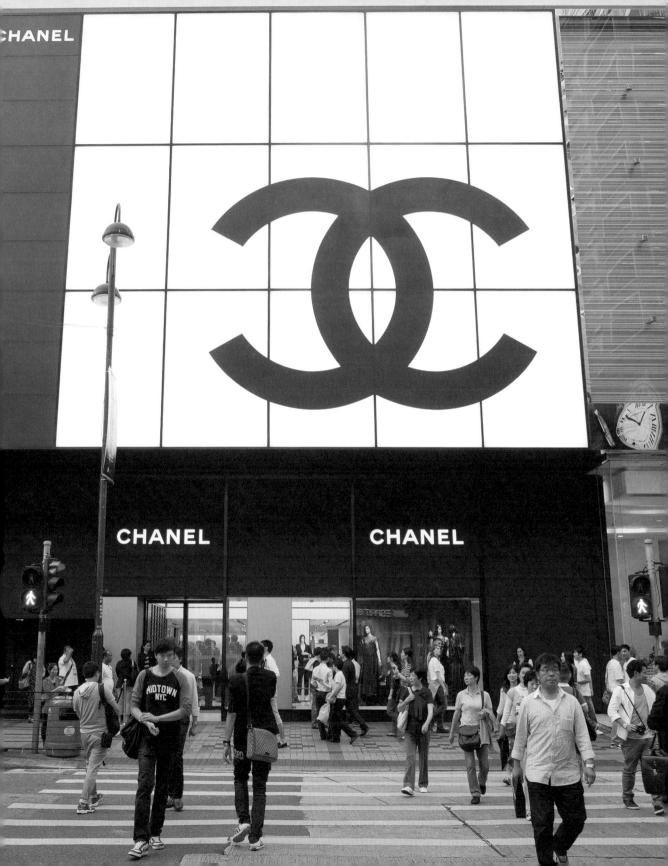

# WHY DO WE BRAND?

Trust is one of the key reasons why we brand. As a result it has become central to the marketing of almost all products and services, used to build awareness and extend customer loyalty. Why we brand therefore goes beyond just a logo and encompasses the whole product concept, as well as the promise to deliver quality and predictability.

A successful brand uses its unique set of values to drive a successful business strategy – to encourage consumers to choose it over its competitors. Therefore a successful brand is one that achieves a high degree of recognition by consumers. However, this relationship is based upon reputation, so for a brand to retain its position, it must ensure that it continuously fulfils the customer's expectations.

*'The primary function of brands is to reduce our anxiety in making choices. The more we sense we know about a product, the less anxious we feel.'*

*Nicholas Ind, writer and partner in Equilibrium Consulting*

# HOW DOES BRANDING WORK?

In its simplest form the practice of branding is about creating differentiation, making one product or service seem different from competitor products. Brand values are the core beliefs or philosophy that a brand upholds, and which differentiate it from its competitors. Another way of characterizing a brand is by identifying its brand personality. One way of identifying this is by using social psychologist Jennifer Aaker's 'Dimensions of brand personality' framework, which uses a set of human characteristics to characterize a brand. These are grouped into five core dimensions:

1. Sincerity: domestic, honest, genuine and cheerful

2. Excitement: daring, spirited, imaginative, up to date

3. Competence: Reliable, responsible, dependable, efficient

4. Sophistication: glamorous, pretentious, charming, romantic

5. Ruggedness: tough, strong, outdoorsy

*'Branding is principally the process of attaching a name and reputation to something or someone.'*

*Jane Pavitt, Head of the History of Design Programme at Royal College of Art, and author of* Brand.New

This technique can be used to distinguish between brands that otherwise belong to a similar product category – for instance, Land Rover falls into the rugged category, while Ferrari represents the sophisticated – and is often used by design agencies to underpin the creation of unique brand values. Its use has helped to transform the way designers consider communicating with target audiences, and plays an important role in the creation of techniques that drive today's vibrant, social-network driven brand communities.[3]

If successful, a branding strategy will create the perception in the mind of consumers that there is no other product or service on the market quite the same. As a brand is ultimately a promise made to a customer to deliver consistently, branding is therefore the act of creating a physical set of attributes – a brand name, brand identity, strapline and so on – along with less tangible assets, such as the emotional benefits offered by the brand.

To succeed in branding you must understand the needs and wants of your customers. There are many different ways to create a successful branding strategy, but most design agencies start with research. The practical step-by-step processes involved in designing the final brand are covered in detail in the later chapters of this book, but they can be reduced to five key stages:

1. Customer research and visual enquiry

2. Concept development

3. Design development

4. Design implementation

5. Testing

Many branding agencies use this staged design method as it incorporates a holistic approach to developing an identity, i.e. it considers the needs, desires and aspirations of the target consumer, the current market and competitive products or services, and it ensures that the client is involved in making key decisions during the process.

3   See pivotcon.com/research_reports/whitli.pdf  which shows how a
    new tool extends the power of brand personality to create powerful
    new options for brands.

# THE HISTORY OF BRANDING

*'In some ways life has not changed much over the last 2,000 years. The fundamentals of living, our instinctive human needs, are essentially the same.'*

*Robert Opie, consumer historian and founder of the Museum of Brands, Packaging and Advertising*

Perhaps the most popular marketing myth is that branding began in the great unfenced prairies of America's Wild West, where cattle men would literally 'brand' their stock with a red-hot iron, signifying 'This cow belongs to me and is my property'. However, Giles Lury, author of *Brandwatching: Lifting the Lid on Branding*, traces branding back to much earlier – around 9,000 years ago – when a Roman oil-lamp maker began stamping the word 'Fortis' on his lamps, thereby providing the first-known use of a trademark.

Lury suggests, though, that the modern approach to branding was not developed until the nineteenth century, when a rapid rise in the standard of living due to the Industrial Revolution led to the development of a new mass market. As populations grew rapidly and moved from the countryside, where families had been able to grow their own food, into towns and cities, they lost their ability to be self-sufficient, and so a new market for manufactured goods was born. Mass distribution, via the development of the

railways, ensured the viability of the mass market, while a substantial rise in literacy led to the growth of newspapers and other forms of mass communication, creating a platform for advertising. Manufacturers began to develop successful communication strategies, giving birth to the modern concept of branding. Lury quotes Wally Olins and his description of this simple, but highly original process:

> It was to take a household product, a commodity, no different fundamentally from any other made by any other manufacturer, and endow it with special characteristics through the imaginative use of name, packaging and advertising ... They advertised them heavily and distributed them widely. The achievement of those companies was prestigious.

The success of some of these early branding pioneers continues even into the twenty-first century. For instance, Kellogg's first filed its company papers in 1906, after inventing its corn flakes almost by accident in 1898; it is now

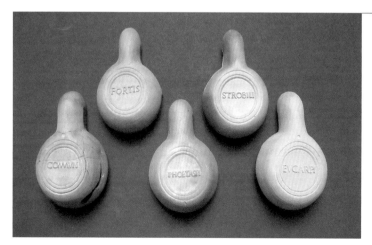

'Firmalampen' (factory lamps) were one of the first mass-produced goods in Roman times. These examples, found in Modena in Italy, clearly show their brand names stamped in the clay bases.

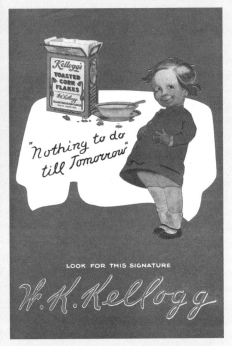

LOOK FOR THIS SIGNATURE

*W. K. Kellogg*

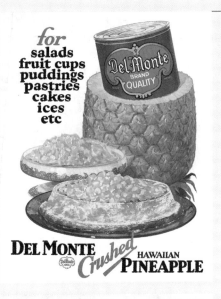

**for**
salads
fruit cups
puddings
pastries
cakes
ices
etc

**DEL MONTE** *Crushed* HAWAIIAN **PINEAPPLE**

**Top, far left:** Possibly one of the world's best known brands, Kellogg's was founded in 1906 by two American brothers, Will Keith Kellogg and Dr. John Harvey Kellogg, who changed breakfast forever by flaking wheat grains.

**Top, left:** Del Monte created its 'shield' brand in 1909. Putting their brand promise right at the heart of the logo, the company reassured its customers with a seal that was, in their words, 'Not a label – but a guarantee'.

**Bottom, far left:** The Wrigley's Spearmint wrapper design has remained remarkably unchanged since its introduction in 1893. The design incorporates the distinctive single-headed spear emblazoned with the word 'spearmint'.

**Bottom, left:** Marmite is a dark, tangy yeast-extract spread. Originating in the UK in 1902, the packaging was similar to a French casserole dish known as a *marmite* (pronounced MAR-meet) – possibly the inspiration for the brand name.

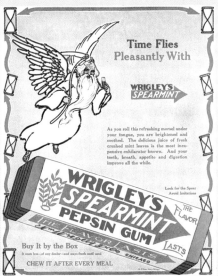

**Time Flies Pleasantly With**

**WRIGLEY'S** *SPEARMINT*

As you roll this refreshing morsel under your tongue, you are brightened and soothed. The delicious juice of fresh crushed mint leaves is the most inexpensive exhilarator known. And your teeth, breath, appetite and digestion improve all the while.

Look for the Spear
Avoid Imitations

**WRIGLEY'S SPEARMINT PEPSIN GUM**

THE FLAVOR LASTS

Buy It by the Box

CHEW IT AFTER EVERY MEAL

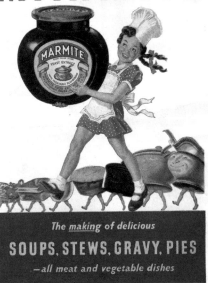

**MARMITE**

The *making* of delicious
**SOUPS, STEWS, GRAVY, PIES**
*– all meat and vegetable dishes*

considered the most successful cereal company in the world. Del Monte has been the leading manufacturer in canned fruit since 1892. The year 1893 saw the introduction of Juicy Fruit, the

oldest brand in the Wrigley family of chewing gums, launched just a few months ahead of Wrigley's Spearmint. And jars of Marmite were first placed on the shelf in 1902.

The use of clever marketing and advertising was one reason that these brands became so successful. However, they still retained their position more than a hundred years later because they also offered a real consumer benefit. Buying products in the nineteenth century could be a highly risky exercise – many were contaminated by cheap 'fillers', used to pad out the goods and increase profit. Some of these products were harmless, but others could lead to serious ill health. As Lury explains, 'Brands, with their superior packaging and promise of consistent high standards, could offer a persuasive alternative – an easily recognizable and reassuring guarantee of quality.'

Bernd Schmitt and Alex Simonson, in their book *Marketing Aesthetics*, propose an alternative origin for modern branding practice – the creation in the 1930s of consumer packaged goods by manufacturers such as Procter and Gamble. They argue that the modern concept of branding was then fully realized in the late 1980s and early 1990s, when marketing managers realized that short-term financial targets were not offering the support brands needed to help them gain status in the marketplace. As a result, companies started to reject an ad hoc approach that responded to changes in markets and consumers in a reactive way, and began to create proactive, long-term 'brand strategies', supported by complex research into consumer purchasing choices.

*'The Internet and in particular the advent of social media means that the number of contact points a customer has with a brand has proliferated.'*

Jane Simms, freelance business journalist

# HOW ARE THINGS CHANGING?

In the last few decades there have been significant changes in the way individuals communicate and are communicated to. Traditionally our purchasing decisions were made in-store, often influenced by television, radio, billboard or magazine advertising. Brands reinforced their message through beautiful packaging, clever sponsorship and product placements in television programmes and films.

However, as Glen Manchester, CEO and founder of global technology company Thunderhead.com explains: 'There is a fundamental shift taking place in the way that brands build relationships with consumers, driven by the combined forces of social and mobile technologies.'[4] The Internet has provided the perfect platform for two-way communication between individuals and brands, with instant opportunities for consumers to capture 'real time' experiences through the use of social media such as Facebook and sites including Instagram, Snapchat and Tumblr. These forms of communication also allow brands to engage with their customers 24 hours a day, allowing consumers to be involved with a brand in ways traditional 'static' media can't achieve.

The advent of smartphones and tablets has revolutionized the speed and volume of messages which brands can communicate to consumers, and emails, instant messaging, RSS feeds and social media offer a dazzling array of digital contact points. These points of contact between a brand and a customer are known as *touchpoints*, and these help brands to maintain a prominent presence in the minds of consumers.

4    Glen Manchester, *Raconteur Magazine for the Times Newspaper* (supplement to *The Times*), 17 July 2012

# THE FUTURE FOR BRANDS

Brands have now been given the chance to transform themselves again. These new technologies enable them to exist beyond advertising and the products they produce. They can even become a part of an individual's lifestyle, thanks to Twitter and Facebook. In the last decade these new forms of global mass communication have allowed billions of conversations between consumers previously unknown to each other. They enable interaction between tens of millions of people everyday, and generate billions of website hits each month.

It is not only how we now interact that has changed but where and when. The mobile phone is now far more than a two-way communication device. The convergence of mobile technology, the Internet and location-based systems such as satellite navigation now offer us immediate and continuous access to entertainment, news, information, our friends, family and colleagues wherever we are, at any time.

Smartphone users can now use a whole host of personally defined apps, to perform tasks ranging from financial transactions to bird-spotting, and the advent of NFC-enabled handsets for mobile payments means consumers will soon no longer need to carry a wallet. Experts are predicting the next big step-change in technology to be the arrival of multiscreen services that allow consumers to seamlessly move from phone to tablet to computer to TV, providing cloud-based syncing of content, experiences and online purchases. Bar code and QR code marketing will become more sophisticated too, designed to make consumers aware of what a product is and how to use it. Samsung has now even designed a wearable digital device (the Gear 2 and Gear 2 Neo) that removes the need to carry a phone at all. These devices provide 'enhanced wearable experiences' for fitness, shopping, social

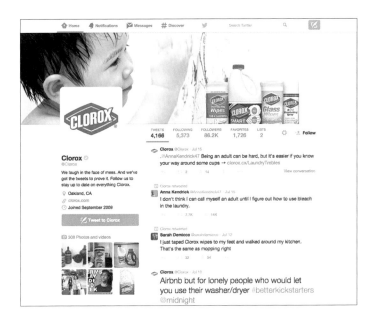

From fashion to cleaning product manufacturing, top brands in many different categories are utilizing Twitter to help 'humanize' their brand, facilitating a more personal connection with their followers.

media, music, news and even sleep management, all offering the opportunity of enhanced brand experiences and new touchpoints.

We are living in an age where we can be always on, always connected, and consumers are becoming increasingly sophisticated and educated, consuming only what is relevant to them. The challenge for brands, therefore, is to become part of the big link by offering immediacy, flexibility, portability, interactivity and ownability, engaging with their customers at deeper and even more emotional levels.

*'... for long-term value, brands need emotional as well as technological appeal. Indeed, [forward-looking companies] will have to invest in their brand as their major sustainable competitive advantage.'*

*Rita Clifton, branding expert and previous chairman of Interbrand*

# MAINTAINING BELOVED BRAND STATUS

Rather than simply avoiding failure, what a brand ultimately aspires to is to achieve a strong emotional connection with its customers – to become, and remain, what is often referred to as a 'beloved brand'. Even once this status has been achieved, it is important to ensure that it is not taken for granted. There are a few strategies that can be followed to help ensure this:

1. When thinking about who you are, keep the brand's promise front and centre in your mind. You need to be either better, different or cheaper. Challenge yourself to stay relevant, simple and compelling.

2. Keep challenging the status quo to maintain an experience that over-delivers the promise. Create a culture that attacks the brand's weaknesses and fixes them before the competition can attack. With a beloved brand, the culture and brand become one.

3. Keep the brand story clear and simple, through great advertising in paid media, but also through earned media either in the mainstream press or through social media.

4. The most beloved brands have a freshness of innovation, staying one step ahead of their consumers. The idea of the brand helps, acting as an internal beacon to help frame research and development. Every new product has to back that idea.

5. Make focused strategic choices that start with being honest with yourself. Find a way to listen to your consumers and stay ahead of trends. Watch for dramatic shifts because they can really open a door for a competitor. It is easier said than done, but do not be afraid to attack yourself even if it means cannibalizing your current business. A good defence starts with a good offence.

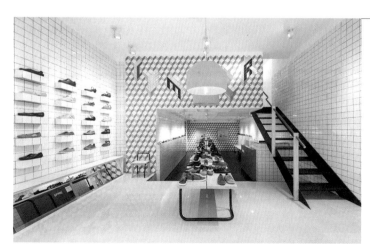

This Camper store in Santander, Spain is part of the Camper Together project, in which leading architects and designers create Camper stores that reflect their own vision of the brand. In this case, Tomás Alonso designed the store using his two guiding principles – a sparse use of materials and an understanding of our relationship with objects – while also reflecting Camper's brand values of freedom, comfort and creativity.

# Uniqlo

Over the last few years, switched-on brands have extended their communication into designing their own branded apps. Uniqlo, a Japanese clothing company, has produced a number of notable app options. Designed to support and improve consumers' daily lives by making everyday routines more fun, engaging and joyful, 'Uniqlo Wake Up' (pictured here) 'Uniqlo Calendar' and 'Uniqlo Recipe' have been created in the hope of becoming indispensible tools. The goal is for the brand to achieve 'beloved brand status' in the hearts and minds of their consumers.

Are these just gimmicks, though? Why has Uniqlo invested so much in a range of apps that have little connection to their sales of fashion apparel? The answer is simple – they are conveying brand values. By creating useful lifestyle utility apps, Uniqlo is subtly conveying a concept – perhaps best summed up as 'simple things' – that captures their essence and plays to their core values. When we wake up, cook a meal or check our to-do list on the calendar, Uniqlo's message is being delivered. It will be interesting to see what follows next, and whether this strategy will work.

Uniqlo Wake Up offers a peaceful rousing from bed, using calming vocals and music influenced by the weather, composed by Yoko Kanno.

If it's raining, your wake-up music will be sombre. If it's sunny, the app will play a happier tune. The app also sings the time, date and weather outside when the alarm goes off, and it comes with multiple language options.

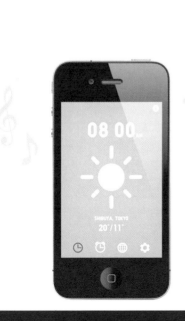
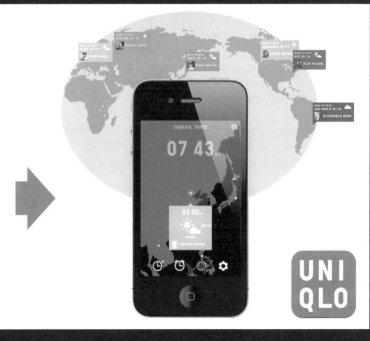

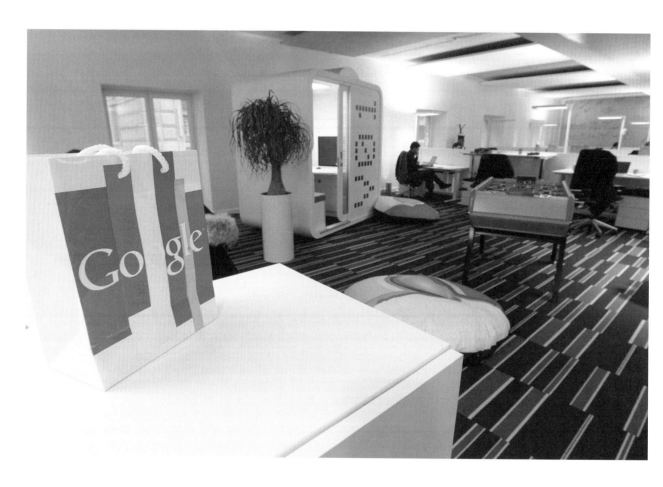

An inside view of Google's new headquarters in France demonstrates the importance the company places on the design of 'internal branding', used to build a holistic experience for its employees.

# CHAPTER 2: BRAND ANATOMY

This chapter looks at the key components and structure of a brand and its audience – its internal and external anatomy – together with the terms used in the industry to define these. This is then followed by a discussion of the key practical considerations for design agencies and their clients before embarking on the creative process of developing a new brand identity.

# LOGOS

A logo, brand mark or brand icon is a deceptively simple device. It employs a combination of shapes, colours, symbols and sometimes letters or words in a simple design that symbolizes the values, quality and promise offered by the manufacturers of a product or service. The Greek word *logos* appears in the first line of John's Gospel in the Bible and translates as 'word'. The use of logos has a long and distinguished history, having been applied to coats of arms, coins, flags, watermarks and the hallmarks found on precious metal. Traditionally, a logo was used to record the origin of a person or object in order to highlight its value through its connection with a prestigious family, place or maker.

Modern trademark laws date back to the late nineteenth century. The advent of large national corporations selling their goods to a growing consumer market created an issue of identity. How could they signify the quality of their products, and distinguish them from inferior goods or commercial rivals? The answer was a unique 'trademark', as a logo is sometimes known. This legal system enabled companies to register a name and designed identity (similar to a patent for product designs), which then enabled them to take legal action against any unauthorized use of their mark.

The red triangle of the Bass Brewery was the first trademark to be registered in the UK under the Trademark Registration Act in 1876. A registered trademark is signified by a small symbol ® next to the logo or brand.

A logo can take almost any form. Some use words made unique by a bespoke typeface, others use pure symbols; many use a combination of the two. They can be defined according to a number of general categories, including:

**Pictorial marks.** The Apple and WWF logos are examples of this approach, where a well-known object has been stylized and simplified.

**Abstract or symbolic marks.** A symbol that embodies a big idea, as used by the multinational corporation BP and car company Toyota.

Bass, founded in Burton upon Trent in the UK by William Bass in 1777, was a pioneer of international brand marketing. Its distinctive red triangle was the first ever to be registered.

**Far left:** Ships were first legally required to carry flags showing their nationality during the Age of Sail in the seventeenth century; these evolved into today's national flags.

**Centre, left:** In medieval times, a coat of arms was used by knights to help identify themselves. These were symbols unique to an individual, family, corporation or state.

**Left:** A hallmark is a unique set of markings applied to a sterling silver object that is to be sold commercially. They are used to indicate the purity of the silver and the mark of the manufacturer or silversmith.

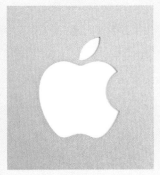

Pictorial marks

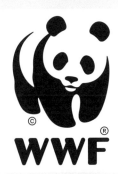

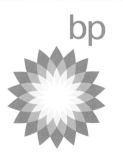

Abstract or symbolic marks

Symbolic letterforms

Word marks

Badge marks

Brand accessories

**Symbolic letterforms.** Where a letter is designed into a stylized form that communicates a specific message, as with multinational corporation GE and consumer goods company Unilever.

**Word marks.** Probably the simplest form, where the name of the company becomes the logo through the use of a unique typeface, as with retailer Saks Fifth Avenue and chemical company DuPont.

**Badge marks.** Where the company's name is connected to a pictorial element, such as TiVo's smiling television set and Innocent's haloed face.

**Brand accessories.** A range of logos that can be used independently to allow flexibility of design, as used in this design by 2x4 for the Brooklyn Museum. This approach is increasingly popular as it allows for communication strategies across many applications.

# Eurostar

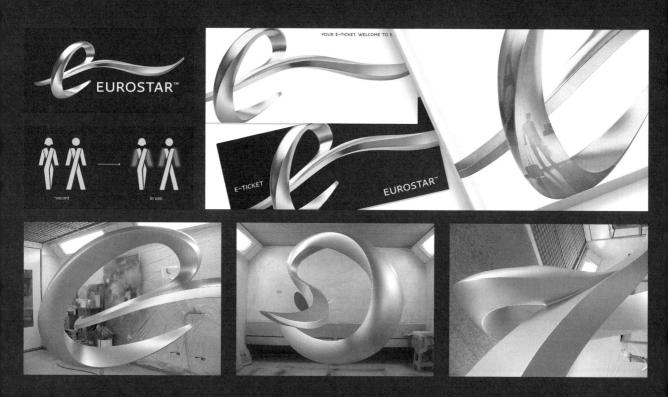

The Eurostar brand created by the design agency SomeOne demonstrates the agency's 'brand world' approach – highlighting the need for brands to be distinctive, simple, practical and unforgettable. The key driver for this complex design project was to ensure the flexibility of the brand, future-proofing it to enable it to adapt to our changing world.

The approach taken was not to rely solely on one idea, but on many: to develop an identity that could morph to any communication environments in which it was placed. In the words of SomeOne's co-founder, Simon Manchipp, 'This rebrand was about creating symbols of change, not a change of symbol.' The strategy saw the creation of multitude ways for Eurostar to create exciting experiences for their customers and staff – one brand, many ideas.

The Eurostar 'brand sculpture' was used to inform three-dimensional typography. The inspiration for the sculpture came from the architect Zaha Hadid and the exploration of movement, capturing the speed of a train through a tunnel,

leaving a wash of air in its wake. The sculpture became the basis for the aesthetic of the brand, and the adaptive logo. The sculpture acted as a source of inspiration, used to guide the design of a bespoke typeface, the aim being to develop brand communication without the need for a traditional logo. By using the typeface with its signature swash characters, its use alone could then express the brand.

Eurostar's 'Fresco' typographic family, with its long flowing line representing the idea of effortless travel, includes swash characters for both upper and lower case, as well as special characters and numerals. In addition to the typography and brand icon, the team also designed a range of pictograms.

The response from Emma Harris, Director of Sales & Marketing at Eurostar, summarizes the success of the final design: 'I didn't consider a bespoke typeface to be part of the end result … but now we have it I can't imagine not having one. It's incredibly useful to have it as part of the brand toolkit, and it looks beautiful.'

Whatever the approach that is chosen, though, the strength of a brand identity ultimately lies in how successfully it embodies the desired meaning of a brand, and the speed of recognition by the target audience. On its own, a logo is just a mark. For it to become more than a graphic device it must acquire meaning in the mind of the consumer.

Using historical or cultural devices may enhance meaning, but a logo must also reflect the time in which it lives, remaining fresh and up to date. The perfect logo needs to be distinctive, simple, flexible, elegant, practical and unforgettable. It must be distinct from its competitors, avoid clichés and never infringe another brand's trademark. A strong logo that employs a distinctive design can also cross national and cultural boundaries, as images – unlike text – are a universal language.

In addition to emotional impact, a logo must also be functional, since it will likely be used on a whole host of designed promotional materials, depending on the product or service it is representing. From large storefronts, billboards and signage, to magazines, online advertising, TV and printed matter such as packaging, direct mail and stationery, the brand logo must remain both legible and consistent. Where typography is used, the letterform needs not only to be unique and distinctive but also clear, as the logo may appear in reduced form on small items. If it includes illustrated elements, these also need to remain strong when reduced in size, and not fill or merge. Many brands use a limited colour palette for this reason – too much detail can result in lost definition when reduced in size.

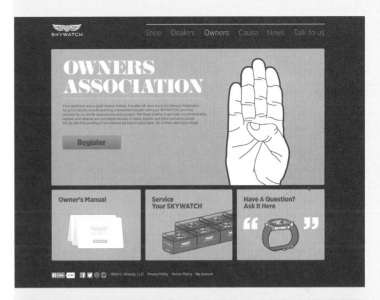

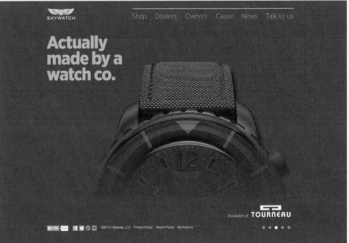

## TIPS & TRICKS

Always ensure that the brand logo is developed and saved as a high-resolution image, at a minimum of 300 dpi. This will ensure that the quality does not deteriorate when reproduced in large formats.

A brand identity must not only be a great piece of design, it must also be functional, since it will be used on a whole host of designed promotional materials.

This brand identity for Skywatch was created by the Los Angeles-based agency Ferroconcrete. Here they demonstrate how they have applied the brand across web-based promotion, where the brand's strong, masculine personality is used to guide the choice of colour palette and images.

# STRAPLINES / TAGLINES

A successful brand identity is made up of a series of interlinked elements that all aim to communicate the values of the brand. Alongside the brand icon or logo, the most memorable is perhaps the strapline – also known as a tagline or slogan. (The word 'slogan' comes from the Gaelic *sluagh-ghairm*, the war cry of Scottish clans.) Made up of a few words designed to link in some way with the logo, the slogan is frequently used in promotional media to reinforce a brand's unique qualities in the minds of the public. A slogan or strapline may highlight unique elements of a product or service being branded, or reference particular promises the brand wishes to make to the consumer. Currently sustainability and other green issues are a key consideration for consumers, and have therefore become a driver for many brands, such as IBM, who have rearticulated their marketing to address this, highlighting their green credentials with the strapline 'A smarter planet' – a simple but motivating idea that is now at the heart of their organization's ethos.

A strapline needs to be memorable and offer insights into the values, personality or experience that the brand offers the consumer, distinguishing it from its competitors. It is usually a short sentence that defines what the brand does, how it does it or who it does it for, created to have an influence on consumers' emotional relationship with the brand. Sometimes the designers themselves will create the strapline as part of their own creative outcomes; at other times the task will be given to a copywriter or specialist agency, and they will need to define and develop a unique written tone of voice to link with the visual one created by the designers.

There are several categories that can be used to define different communication approaches:

**Descriptive.** This helps to describe the product service or promise, such as Innocent's 'Nothing but nothing but fruit'.

**Superlative.** This defines the market position as top of its category, for instance BMW's 'The ultimate driving machine'.

**Imperative.** Usually a command or direction for action, such as Nike's 'Just do it'.

**Provocative.** This may use a thought-provoking question, or irony, for example, VW's 'Think Small'.

**Specific.** This defines or expresses the business or the brand's product, such as chemical company DuPont's 'Better things for better living through chemistry'.

## TIPS & TRICKS

When considering the aesthetics of a strapline or tagline as part of the designed communication strategy, the quality of typography, its scale in relation to the logo and the colour used all need to harmonize with the design of the brand icon so that it can be easily trademarked along with the choice of words.

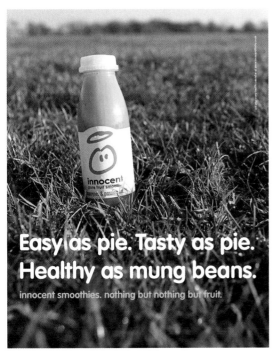

**Easy as pie. Tasty as pie. Healthy as mung beans.**

innocent smoothies. nothing but nothing but fruit.

Descriptive

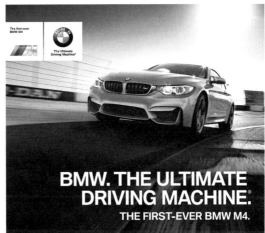

**BMW. THE ULTIMATE DRIVING MACHINE.**
THE FIRST-EVER BMW M4.

Superlative

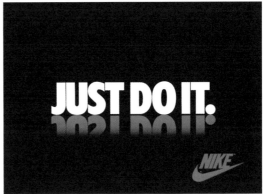

Imperative

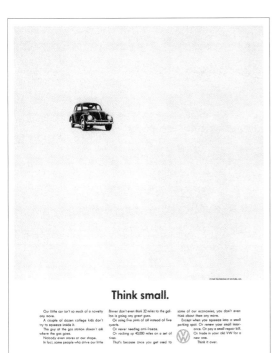

**Think small.**

Proactive

Specific

# APPEALING TO THE SENSES

It is important to remember as a designer that branding is not solely a visual form of communication – appealing to all the senses is a far more powerful way to communicate a message effectively. From the feel of the dimpled effect on an Orangina bottle to the distinctive smell of a particular airline interior, branding designers can appeal holistically to a consumer's senses.

A recent study on memory and the senses carried out at the Rockefeller University revealed that in the short term we remember just 1 per cent of what we touch, 2 per cent of what we hear, 5 per cent of what we see, 15 per cent of what we taste and 35 per cent of what we smell. Smell is the most sensitive of all our senses, and its links to pleasure and wellbeing, emotion and memory have a huge influence on mood. In the late 1990s Singapore Airlines were one of the first brands to take advantage of this by commissioning a unique fragrance, called Stefan Floridian Waters, which was worn by the cabin crew, used on hot towels and sprayed throughout the cabins. The fragrance became familiar to frequent flyers, triggering positive memories of previous experiences with the airline.

Sonic branding – traditionally known as 'jingles' – is no longer restricted to television advertising. Examples are now heard everywhere, with or without words. Sometimes also known as 'earworms', these bits of melody worm their way into our consciousness to manipulate our emotions and connect us to a brand. They have become a vital tool in the arsenal of brand communication techniques, and the sonic branding industry is now worth millions. Nokia's ringtone, Intel's four-note bongs and the McDonald's 'I'm lovin' it' refrain are all well-known masterpieces of sonic branding. Creating a few sections of music is not as easy as it sounds, though, and can take many months to compose. Elisa Harris from Cutting Edge Commercial, a consultancy providing sonic branding for the likes of Disney, McDonald's and Mercedes, explains a sonic brand is created by taking a word or concept and then turning it into sound. 'It's rare that we get a word or a value that we can't put a piece of music to.'

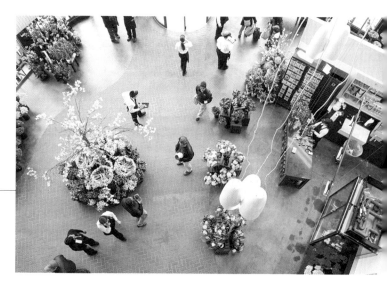

Supermarkets and shopping malls demonstrate their appreciation of the importance of smell in connecting with their customers, by placing their floral departments at the entrance to their retail environments.

Taste also plays a crucial role in our lives, at a social, physical and emotional level. It is often employed in branding in simple ways, such as sampling or free-tasting promotions. Gustative branding techniques, as they are known, are also used in advertising, as with the 2007 Skoda Fabia television campaign, which featured a cake that looked exactly like the real car. The idea was to project Fabia as a 'sweet and tasty' car, and within the first week of the campaign sales grew by 160 per cent.

Touch can induce a highly personal association with a product and, in turn, a brand. It is no accident that the metallic surface of the iPhone has been developed to create a unique surface that has become associated with the brand even without seeing it – Apple appreciates the power of a multisensory brand experience more than most. Famous for creating a unique brand experience in its store environments, it uses all the senses to enable a holistic customer experience. The Apple 'concept store' provides the opportunity for the customer to see, touch, listen and even smell Apple, as well as interact with its carefully trained Apple 'geniuses', tasked to support every Apple need.

Research has found that an experience involving as many of our senses as possible is far more effective at building brand recognition than an approach involving just one sense, so it is not surprising that the use of sensory branding has grown rapidly since the millennium, aided by new technologies and materials, and is predicted to play a major part in future strategic branding.

# BRAND ARCHITECTURE

Brand architecture is a way of describing the hierarchy of brands within a single company's portfolio. A common model will consist of an overlying master brand (also called a corporate, umbrella or parent brand), with a number of separate, unique, trademarked sub-brands beneath it. (A good example of this is Microsoft, who operate a range of sub-brands, including Word and Xbox.) This strategy enables an organization to target many different customers by developing a variety of brands using different names, colours, imagery, logos, promises, positions and personality traits. Ultimately, brand architecture is about organizing the relationships with different brands and customers to reach business objectives.

The term brand architecture can also be used in a broader sense to define all the attributes that make up a brand's communication strategy – including physical design elements, such as the logo, and the emotional elements that define the brand's characteristics. To develop a successful sub-brand, it is important that these elements remain consistent, to retain the focus and strength of the original brand.

# BRAND FAMILIES

Once an individual brand has achieved a level of success it will often look to grow by extending into new products or services. The original brand thereby becomes a parent, and the new subsidiaries become sub-brands, with a number of sub-brands constituting what is termed a brand family. Each member of the family has its own unique identity, while also reflecting the original values of the parent brand.

Strong brands are created by capturing the minds and emotions of a target audience with a particular product; great brands are those who are able to transcend their original category and come to represent a larger, more powerful meaning or experience. Once a brand has been able to develop this sort of iconic status it is able to 'procreate'. The Orla Kiely story is a great example. Starting her career as a hat designer, her line of products now spans wallpaper, cars, radios and fragrances.

A successful brand extension requires a company to understand clearly how it is perceived by its customers. It must then define products or services that will secure a wider audience, but also retain the original essence of the brand. A strong communication strategy that highlights the purpose of the new brand, and links it clearly to the existing parent brand, is crucial, and the brand identity is where this can be expressed most clearly.

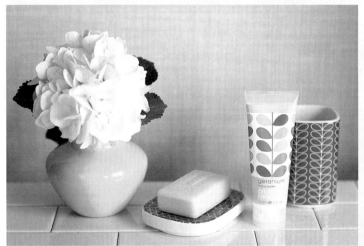

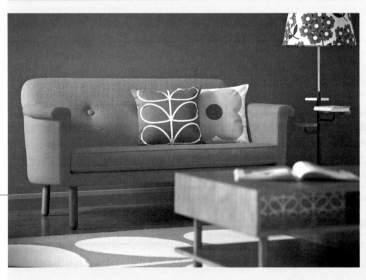

Orla Kiely, an Irish designer working in London, started her career designing hats. Harrods launched her MA collection, and her designs now include homewares, stationery and even cars.

## The use of brand identities

A great example of a 'brand family' is the identities created for the British Broadcasting Corporation. Key to the success of their branding strategy has been the ability to maintain the strength of the parent brand by seamlessly integrating it within their range of sub-brands. The bold, upper case sans serif face, with each of the three letters of the BBC brand contained in a separate box, gives the parent brand a strong, fundamental identity. The strength of this icon ensures it maintains its dominance in the hierarchy when applied to the sub-brands, even though it appears in a smaller font size. Each sub-brand is then developed to give it its own unique identity by the use of a range of typefaces and colours.

Creating a brand family that is able to reference successfully the parent brand within the identity is not an easy task. This example of six of the BBC's 'sub-brands' demonstrates a successful integration of the parent brand within a clear set of individual identities for a range of television channels. The use of a strong colour palette and a range of unique typefaces enable each individual channel to create a strong personal identity, whilst still signifying its relationship to the BBC.

In some cases a brand can become even more than a family, developing its own dynasty, as with Virgin. In this case a consistent visual identity covers a range of distinct categories, from music to financial services, radio and air travel.

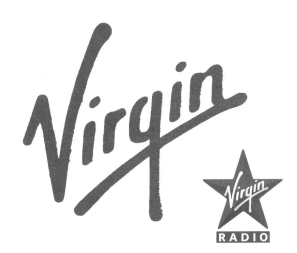

The Virgin brand demonstrates a different strategy for the creation of its sub-brands. Although the parent brand is still referenced, each sub-brand is quite distinct.

# INTERNAL AND EXTERNAL BRANDING

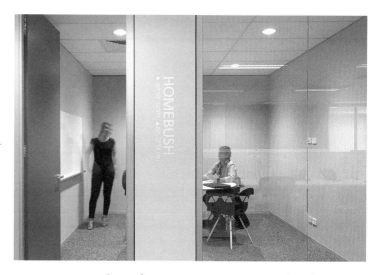

Garmin, the navigation company, commissioned BrandCulture to create a new office environment for their Australian headquarters. Meeting rooms are marked with GPS coordinates, and a triangulation treatment for the walls, images and typography reinforces Garmin's commitment to improving GPS technology.

Brands do not only communicate with their customers; it is vital to the success of a brand that the values externally communicated are shared with those who make, develop and market it. This facilitates a full engagement within the company, ensures a higher level of commitment and enhances performance. Sharing key aspects of a communication strategy with employees also helps synchronize the personality of a brand and its corporate culture, as does keeping employees informed and involved in new initiatives.

This can be done most effectively through a strong internal communication strategy that helps to explain and reinforce the brand promise. Employees are now more open than ever about their work life, 'chatting' on Twitter and Facebook to share and amplify their messages. As a result, companies like Nokia are taking advantage of this form of communication to enhance the working experience and attachment to the brand through brand evangelist programmes that use volunteers within the company to bring the brand to life, both within the workplace and the wider community.

Graphic communication can play a key role in the way a brand is communicated internally, whether via intranet sites (internal websites only viewable by employees), monthly newsletters or brand language guides, exploring the appropriate tone of voice for emails and other correspondence. Even the way offices are decorated and configured will influence the way the employees feel about their role in promoting the brand.

Employees themselves can also be directly influential in how the brand is perceived. Brand champions are individuals who are responsible for cultivating support for a brand, internally and externally, by spreading its vision and values. The more employees with this sense of identity with their brand, the stronger the brand equity becomes. Nike and Singapore Airlines emphasize this approach within their corporate structure, and demonstrate how much an organization can benefit from strong and dedicated brand champions.

Another company that is well known for using this 'from the bottom up' approach is Google. Founded in 1998 by Larry Page and Sergey Brin, Google gave its employees a clear vision of how it wished to operate, with the corporate motto, 'Don't be evil'. This is understood as a moral code, guiding relationships and undertakings within the organization. Google's employees also enjoy a high level of individual accountability; they must spend 70 per cent of their time on current assignments, but are then free to spend 20 per cent on related projects of their choosing, and 10 per cent on new projects in any area they desire. This preserves the spirit of innovation the company was founded on.

# BRANDING TERMINOLOGY

Having a shared understanding of the terms used to define the various aspects of a brand is important for both the design team and client. For instance, how do brand *values* differ from the *promise*? The following section provides definitions of key common branding terms.

## The philosophy

Before the physical designing of a new identity begins, some fundamental questions need to be asked of the brand – including, simply, 'Who am I?' At this early stage the designer needs to probe the client to uncover the key functions of their product or service – put simply, what it does. An understanding of the brand's philosophy will then begin to emerge.

In most cases the first stage in developing the brand philosophy is to research the company's own corporate philosophy. This is primarily a distillation of its culture or ambience, developed into a group of core values that inform all aspects of its business practices. The philosophy both guides employees as part of internal branding, and provides the structure for external brand communication strategies.

Google is a great example of a company that makes their philosophy explicit to all stakeholders, by listing on their website '10 things' written when Google was just a few years old. This set of key values is revisited regularly, ensuring their philosophy remains true to their principles. The list includes statements such as 'It's best to do one thing really, really well', and 'Great just isn't good enough'.

## The promise

This usually summarizes what the brand promises to deliver. It is written to help the designers develop the emotional characteristics of the brand that will help it to communicate directly with its audience and differentiate it from the competition. If the design is for an existing brand, the promise needs to remain consistent with the brand's previous offer.

A brand promise is not the same thing as a strapline or slogan. Coca-Cola's promise, for example, is 'To inspire moments of optimism and uplift', whereas its slogans – which are regularly updated to keep communications fresh – include 'Life tastes good' (2001).

Virgin's promise is similar to Coca-Cola's in that it does not describe what the company does or provides. Coca-Cola doesn't talk about selling the best soft drinks in the world, and Virgin's promise – 'To be genuine, fun, contemporary, and different in everything we do at a reasonable price' – does not reveal anything about its travel credentials. Good brand promises like these only talk about how a company promises to deliver a solution to a need or desire, or to fulfil an aspiration. A good brand promise will stand the test of time. For a brand to have longevity, the promise needs to be delivered time after time to create a strong, loyal consumer base.

## 'Living the brand'

Consumers are increasingly purchasing brand 'experiences' as opposed to just branded commodities or things. Therefore the creation of successful brand stories, attributes and associations, which are all largely intangible and often symbolic, is becoming increasingly important in the development of a successful brand strategy. A brand that achieves iconic status is one that has been taken into the hearts and minds of its consumers, with the ultimate success being the existence of a brand tribe – a formal or informal group of like-minded people who share the same passion and loyalty for a brand, adopting its values and applying them in their own lives. Brand tribes also have a strong influence on how a brand is perceived and ranked by other groups.

Brand tribes often grow up around small, specialist brands that have a specific set of values, appealing to a niche market. The organic clothing brand Howies, and the online eclectic homeware store Pedlars, are two examples. However, big brands can achieve this sort of brand loyalty too, particularly in youth markets. For instance, luxury fashion brand Burberry has recently embraced the use of social media to communicate to its existing followers, and to cultivate new fans in places like China. According to the *Financial Times*, the company spends over 60 per cent of its marketing budget on digital channels. It is now officially the most popular luxury label on Facebook and Twitter, with more than 600,000 followers on the latter.

## Brand values

There are two key definitions of brand value. There is the value of a brand on a balance sheet, which obviously has key importance to the owners of the brand. However, probably more importantly, there is the perceived value of a brand by its consumers. These values are less tangible and refer to the emotional attributes associated with a specific brand. In the twenty-first century the question of authenticity has become increasingly important – consumers want to know what a product contains, how it works, whether it fulfils its promises. Brand values highlight why and how a brand does what it promises.

Andy Green, brand consultant and author, describes brand values as 'things you do even when it hurts.' He helps his clients to identify their values in simple steps: 'On my creativity, brand story and brand workshops I always advise delegates to identify their five top values.' Andy also champions the work done by Jackie Le Févre, a values specialist and founder of Magma Effect who created AVI, an online interactive profiling resource that is fast becoming one of the leading values tools around the world.

A good example of a highly successful outcome of defining key values to define a brand's unique promise is the Innocent Drinks company. Founded in 1999 by three Cambridge University graduates, who started by selling smoothies at a music festival, the brand now sells more than 2 million drinks a week, with Coca-Cola currently owning a 90 per cent stake in the company.

Innocent, as its name suggests, uses natural ingredients in its products, and espouses key values of healthy eating and sustainability, marketing products with the tagline 'Nothing but nothing but pure fruit'. The brand values of sustainable nutrition, sustainable ingredients, sustainable packaging, sustainable production and sharing profits are clearly defined on the website, so the brand needs to ensure that it not only fulfils these values practically, but also backs them up visually – through the brand mark itself as well as in all promotional and communication strategies.

How Innocent 'lives' its brand values:

- By using green electricity at its headquarters, Fruit Towers
- By sourcing fruit from suppliers who look after their workers and the environment
- By sourcing all bananas from Rainforest Alliance-accredited farms
- By donating 10 per cent of all profits each year to charities, primarly through the Innocent Foundation, which funds organizations working around the world on issues including sustainable agriculture and food poverty

The Innocent product range has now expanded into other healthy-eating areas, including veg pots and squeezy fruit tubes for children, and the key values of the company have grown to accommodate this expansion. Innocent not only encourages healthy eating, but also takes advantage of the popularity and leverage of the brand to support sustainable projects in the underdeveloped world.

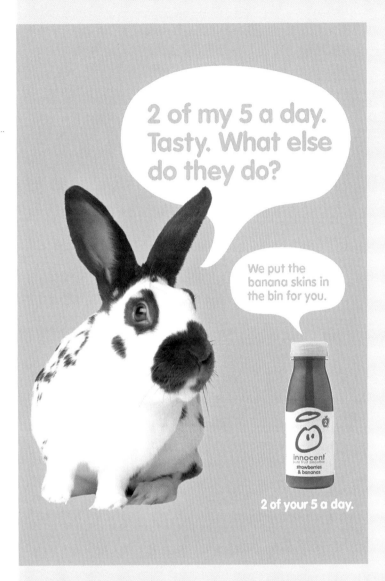

The style and 'tone of voice' created for Innocent emphasizes the company's philosophy and values. All their brand communication is designed to highlight its ethical stance, but in a fun and engaging manner.

# Brand equity

'Brand equity' is a marketing term used to describe the commercial value derived from consumer perception of a brand name, rather than the product or service it provides. This is witnessed whenever a consumer is prepared to pay additional money for a branded product over a cheaper store-brand alternative. Brand equity can become a highly valuable commodity, enabling companies to expand by marketing new products under the same label. The stronger the brand equity, the more likely that existing customers will buy any new product, associating it with the existing, successful brand. Brand loyalty of this kind is often perceived as one of the most financially valuable aspects of a brand.

However, brand equity is not always positive. A bad reputation will result in negative brand equity, and once a brand has made a poor association in the minds of consumers it can be very difficult to shift. In this case, all the traditional advantages of branding will be inverted. The 2010 BP Deepwater Horizon disaster demonstrated this clearly.

In April of that year, an explosion sank one of BP's offshore drilling rigs, killing 11 workers, and causing one of the largest environmental disasters in history. The financial implications for the company were immense, with end-of-year profits in 2013 down to $13.4 billion, compared with $17.1 billion in 2012. However, the long-term effect on customer and shareholder perception of the brand may last for years to come.

Michael Kaiser from Kaiser Associates, an international strategy consulting company, defines the issues facing brands in managing their equity:

> In our rapidly evolving economy, with greater and greater information flow and rapid innovation cycles, the speed with which customer selection criteria changes and brand equity shifts between competitors is astonishingly fast, and significant damage can be incurred. In a surprisingly large number of cases, however, brand recovery is possible by directly confronting weakness ... A useful starting point for companies in determining their strategy to Brand Equity management may start with a thoughtful examination (and a properly aggregated quantitative measure) of a number of simple yet powerful questions: What do customers want? How do customers think? Who are we beating, and why? Who are we losing to, and why? ... In the end, the only thing that matters is what customers think today, and the actions they will take tomorrow.

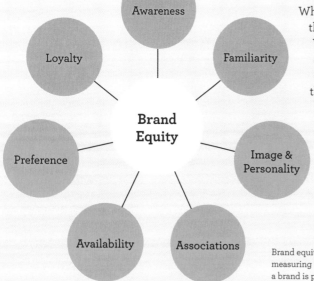

Brand equity can be determined by measuring seven key aspects of how a brand is perceived by consumers.

# The brand story

A brand story gives meaning to a brand and defines what it is and what it does. Consumers are becoming increasingly educated about retailing, and often demand to know where their products come from and how they are made. Brand stories that offer a background to products being sold are therefore an effective way of engaging with customers. These stories can be highly personal, exploring the lifestyle of the individual maker; they can be also be fun, educational or even challenging. It is important, though, to determine the right tone of voice for the target audience.

Brand stories are not fixed; they can develop over time to capture and respond to changing customers and markets. Key to the development of a successful brand story, though, is defining the core truth about the product or service concerned, as this will become the heart of the message. As in a fairy story, this truth is the moral that will make the story endure.

So, can a successful brand story make one object more valuable than another, even if the two objects are fundamentally the same? In 2006 Rob Walker, a *New York Times Magazine* columnist and his friend Joshua Glenn put this to the test with a project called Significant Objects. The pair visited flea markets and charity shops, where they bought a large selection of worthless objects, including an old wooden mallet and a plastic banana, spending an average of $1.28 per object. They then asked 100 talented writers to create short stories about each object. The experiment concluded with the objects being offered for sale on eBay, using the story as the object descriptor. The average price paid was an increase in value of over 2,700 per cent. The mallet – bought for 33 cents – sold for $71 and the banana (25 cents) fetched $76.

The obvious lesson from this is that brands and their packaging, where appropriate, should tell a story. Stories that clearly and creatively reveal the essence of a product, its history or creation, can capture and engage the emotions of the consumer.

To return to the example of Innocent Drinks, the text on the bottle of each of their smoothies demonstrates the benefits of this approach. Innocent are well-known for having pioneered a new way of addressing consumers using a clear story, communicated on packs and through advertising. The brand promise is exploited in a simple and friendly manner, enabling the company to explain who they are and what they do, in terms that speak directly to their consumer.

Susan Gunelius, President & CEO of Keysplash Creative, Inc., explores the importance of narrative in brand communication, 'Stories are the perfect catalyst to building brand loyalty and brand value. When you can develop an emotional connection between consumers and your brand, your brand's power will grow exponentially'. However she highlights the importance of understanding the style of this type of writing as 'different from standard copywriting, because brand stories shouldn't be self-promotional. Instead, you're indirectly selling your brand.' She explains that there are key points that need to be considered, the first being 'showing not telling' that uses descriptive words to evoke emotion. She also highlights the need to develop 'plot'.

If you tell the complete story in one shot, you lose the opportunity to build a long-term relationship with your audience. Instead, pique their interest but don't provide resolution immediately. Leave them hanging with a promise of more, just like the best fiction authors do at the end of each chapter.

Finally she warns against confusing the consumer: 'If your target audience doesn't understand how your story relates to their perceptions of your brand and their expectations for it, they'll turn away from your brand in search of another that does consistently meet their expectations.'

Before any creative activities can take place, the design team need to bring together a range of research findings that will guide the brand creation process. These may include marketing statistics, competitor analysis and consumer demands.

# CHAPTER 3: BRAND STRATEGY

Creating a successful brand is a highly complex activity, undertaken by a team of professionals skilled in different aspects of the process, including brand managers (who oversee all aspects of a brand's promotion, sales and image), account handlers, creative directors, media buyers, marketing experts and, finally, designers. Before any creative work can commence the team develops a clear strategy that will guide the design process. Research is fundamental to gaining a clear appreciation of issues such as the needs and demands of particular consumers, the current market situation, trends and competitors.

A 'brand strategy' defines the how, what, where, when and to whom the brand plans to communicate, alongside highlighting the client's specific goals for the brand. A well-written and implemented brand strategy will encompass all aspects of brand communication, such as identity, packaging and promotion. Particular attention is given to consumer needs and emotions, in addition to considering the competitive environment into which the brand will be launched.

# STANDING OUT FROM THE CROWD

One of the key challenges when developing a brand strategy is to define how the design will create a strong and unique identity. The designer will need to develop a clear visual communication system that will attract the target consumer and differentiate the brand from its competition.

For branded packaging the competition is enormous, with more and more new products vying for attention, particularly in supermarkets. When a new brand hits the street or goes online, the challenge to catch the consumer's eye is equally challenging. So how can a new brand cut thorough the 'visual noise' and make itself seen? The first thing that attracts a consumer tends to be colour, followed by shapes and symbols. The text or the brand is usually the final element to be understood.

## Colour, shapes and symbols

On average, at a distance of 1 to 2 metres (3 to 6 feet), shoppers take just five seconds to find and select a given product. Therefore an appropriate use of colour can increase brand recognition by some 80 per cent, while also serving as an important brand identifier.

Symbols are a nearly instantaneous means of communicating meaning, as with McDonald's 'Golden Arches', the Mercedes star and Nike's swoosh. The associations derived from symbols also become imprinted in consumers' minds through repeated exposure. Often the brand selected has a family connection, having been bought by the consumer's parents, demonstrating that shoppers intuitively gravitate towards familiar symbols.

## Words

Packaging cluttered with too much text fights for attention and often creates confusion. Therefore keeping the design simple is often the best approach, focusing on a single competitive point of difference that distinguishes a brand from its main competition. While colours, shapes and symbols tend to enhance on-shelf visibility, generally the more text used in a design, the less effective these other elements become.

Visual 'noise' is a constant issue for packaging designers. With so many brands competing for attention on the supermarket shelves, often the simplest designs create the strongest impact.

The packaging redesign for Plum Organics' 'Just Fruit' range draws attention to the delicious product inside by keeping the typography to a minimum. It also helped the agency win a Dieline Award.

# UNIQUE SELLING POINT (USP)

M&M's USP is the hard candy coating that guarantees the chocolate 'melts in your mouth, not in your hands'.

American adman Rosser Reeves first coined the term 'unique selling point' in the 1940s. Initially an advertising and marketing concept, it was used to explain a pattern among successful advertising campaigns, where unique propositions were made to customers, convincing them to switch from their usual brands to the one advertised.

The USP – or sometimes 'unique selling proposition' or 'point of difference' (POD) – are all critical in defining a brand's competitive advantage over its competitors, and fundamental to a successful branding strategy. In addition to ensuring that there is a clear differentiation from the existing market, the USP must also include attributes or benefits that consumers will strongly, uniquely and positively associate with the new brand.

Determining the USP for a new product or service demands considerable research of the subject, existing market, current consumer needs and trends. (This may be undertaken by the design agency, or by a specialist research company, as explained in detail in Chapters 5 and 6.) Currently authenticity, environmental concerns and sustainability, food miles and healthy lifestyles are issues that brands are exploiting to help them define their unique qualities. However, to develop strong loyalty from its customers and enjoy continued success, a brand must be honest and able to deliver the promise offered.

When researching the brief, the creative team will also develop an emotional selling proposition, or ESP. This is used widely in advertising, and is similar to a USP, but focuses on the emotional triggers to purchasing.

# SEMIOTICS

'What does it all mean?'

Semiotics is the science of understanding signs. As part of a degree curriculum this subject is often delivered separately from design practice; however, the creation of a successful brand relies not only on good creative design, it also needs to 'mean' something. How we build meaning into the brands we create is a complex art and involves the design of three key elements – the brand name, the icon and often a strapline, or slogan. In our graphic toolbox we have the use of typography, colour, image and style, and our choices for these will be determined by the message we wish to communicate.

Appreciating and manipulating the level of meaning contained within a brand identity, and the consequential subliminal effect this has on consumers and their buying decisions, is the key objective of branding design. This can be explored effectively by studying the layers of meaning captured within an existing brand, and such 'brand analysis exercises' therefore play a key role in the early stages of the design process.

**EXERCISE**

## Brand analysis

To analyze a brand successfully you must first deconstruct it into its main characteristics. For example: What typeface does it use? What colours? Does it include a logo or an icon and what does it represent? How is it constructed? The next phase is to ask why for each of these questions.

Analyzing the meaning within each part can help to determine not only the designers' original intentions, but also the subtle qualities of the brand that has been created, and its intended audience.

A simple way to explore brand semiotics is to undertake a similar deconstruction exercise to those featured here.

1. Choose an existing brand that is made up of an icon and a typeface, and has a strong use of colour. Find a good-quality image to download and print it out.

2. Take each element in turn and research the meaning behind it.

3. Document your findings and analysis by adding your comments to the sheet and using arrows to define your points.

4. Add additional images you find during research to highlight the source of the meanings; this process can also help to define your points.

This exercise is extremely useful (especially for students) as it helps in gaining a greater understanding of the depth of meaning necessary to develop a successful brand. They can then also use the same method, having completed their own brand, to rationalize their ideas and demonstrate their creative thinking.

# Apple

In Walter Isaacson's biography of Steve Jobs, published a few weeks after his death, the co-founder of Apple is quoted as having thought the word behind his iconic symbol and brand name sounded 'fun, spirited and not intimidating'. However the semiotic meaning of the apple goes far deeper in human civilization. For example, one of the Twelve Labours of the Greek mythological hero Heracles was to steal some golden apples belonging to Zeus, while the forbidden fruit mentioned in the Bible has been depicted in Renaissance art as an object symbolizing knowledge.

An apple is therefore a highly symbolic object. It can signify the highly cherished object ('the apple of one's eye'), or the gesture of a favoured pupil towards a special teacher. The bite in one side of the Apple icon could even symbolize the opening of Adam and Eve's eyes after they ate from the Tree of Knowledge. What additional meaning is therefore communicated through Apple's brand identity?

## The use of colour

Historically the Apple logo used a rainbow colour palette. The current symbol has a highly reduced palette of cool, translucent greys, which give the mark a sense of purity and modernity, and highlights its roots in technology.

## The use of style

- The icon has been developed in a pure and symbolic manner, not dissimilar to a road sign in its simplicity, although far more sophisticated in style.

- It is interesting to note that the stalk of the apple does not appear. The leaf therefore has prominence, giving the impression of growth.

- The reflective qualities echo the type of modern materials used by the brand, as well as the feel of the brand's technological products.

- The three-dimensional elements, including highlights and drop shadows, give the brand dynamism and life.

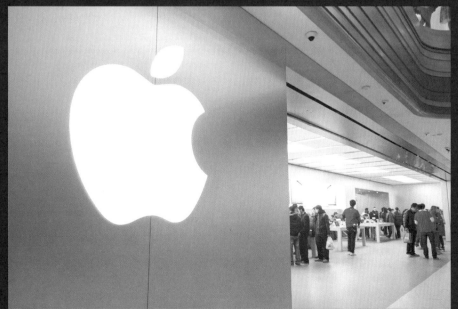

The symbol of the 'bitten apple' used by Apple has many possible connotations, including both biblical and mythological. Although the use of semiotics within a design is clearly apparent, this does not mean that consumers are conscious of these messages. Rather, their meaning is perceived unconsciously, having been shaped in our minds by cultural and historical forces.

# SEMIOTIC TOOL BOX

As stated earlier, there is a range of tools that can be utilized when designing a brand, to ensure that it conveys the desired message.

## Typography

The simplest definition of typography is the art and practice of arranging type. Typography has ancient roots, originating in the first punches and dies used for creating seals and currency. The first moveable metal type was invented in Korea during the twelfth century. The arrangement of type then developed further in the fifteenth century, with Johannes Gutenberg's invention of the printing press.

In modern design the use of typography is very broad, covering all aspects of letter design and application, including typesetting, type design, calligraphy, inscription, signage, advertising and digital applications. An extensive knowledge of typography and typefaces is therefore a fundamental requirement for the professional graphic designer, and an understanding of the historical importance of each face and how it has been used in the past can guide appropriate use.

The first known moveable-type system was created in China in around 1040, but it was the Koreans that developed this technology, making the first metal moveable-type system for printing in around 1230.

The Gutenberg Bible was the first major book printed in the West using the system of moveable type. Published in the 1450s, it marked the start of the age of the printed book in Europe.

The packaging for T/Gel uses an interesting cross-reference of visual languages. Neutrogena employed a clean, pared-back pharmaceutical style to give consumers the impression that their shampoo has been 'scientifically' tested and developed.

In contrast, this elegant packaging for organic olive oil toiletries has used beautifully crafted, hand-rendered typography to enhance its femininity and reflect the products' luxury credentials.

However, there is more to knowing about type than understanding the font families. It is important to appreciate that existing 'languages' appropriate to specific products and services have been built up over time. For instance, pharmaceutical packaging features typefaces that express the medical nature of its contents, while IT brands have developed a style of type that expresses the technical nature of their services, and food and cosmetic brands choose from a range of fonts that communicate the fresh or indulgent qualities of their products. A good understanding of the current semiotic languages used by existing brands will ensure that the appropriate visual language is considered when creating new concepts.

# Colour

Colours have long been used for symbolic effect. Countries have utilized certain colours for their flags and military uniforms, and aristocratic families have employed specific colours for their coats of arms.

Certain colours have also, over time, come to represent particular moods or thought and can therefore be used as visual shortcuts; for instance, yellow or red will communicate a warning. Designers can exploit the symbolic use of colour to express meaning in this way, helping brands to communicate even more effectively. An example is the use of the colour purple.

The pigment used to create purple dye in ancient times came from a mucus secreted by the banded dye-murex snail. Because it was so costly and difficult to produce, it was only used on the most expensive fabrics, and worn by emperors. As a result, it came to be known as 'royal purple'. The colour has continued to signify luxury and, as a consequence, has been chosen by brands such as Milka and Cadbury (which always uses the same Pantone colour: 2685C) to reinforce the quality of their products.

**Top, far left:** Red is one of the most common colours used on national flags, representing the blood spilt by those defending their country. It has been associated with left-wing politics, and is the colour that symbolizes communism.

**Top, left:** In the nineteenth century, the colour blue became associated with authority. Since it was perceived as both serious and authoritative, without being menacing, it was chosen as the colour for police uniforms.

**Below, left and right:** Purple is a colour used by many chocolate brands to express luxury. This association has developed from its use in garments worn since ancient times by persons of power, such as Roman emperors.

# Image

Images can also hold specific meanings, as was seen with the apple. Often objects develop strong symbolic significance over time, so they must be considered in their past historical context. For example, eagles have been used extensively within national symbolism from Napoleon Bonaparte to the Great Seal of the United States, and the double-headed eagle of the Byzantine Empire to the Ghanaian coat of arms. Within branding the eagle has also been used to denote patriotism, particularly by American companies.

In 1856 Gail Borden patented his invention of sweetened condensed milk, a product designed to combat food poisoning and other illnesses related to lack of refrigeration. Condensed milk became a popular staple, but it was the American Civil War that made the Eagle Brand a household name –

during the war the military needed milk that could be easily transported and would not spoil; Borden's Eagle Brand milk fulfilled all their patriotic and dietary requirements.

When considering the inclusion of an image it is therefore extremely important to have a full appreciation of any historical or traditional meaning so that it is used sensitively and appropriately.

Below: The eagle used on Gail Borden's tins of condensed milk reflects its patriotic relationship with the United States of America. The brand played a key role during the Civil War, providing the military with desperately needed foodstuffs that were nutritious but did not need refrigeration.

## Style

Photographers and illustrators develop unique styles to ensure that their work has a creative differentiation, but the styles they use can also have semiotic significance. Cartoons are an interesting example. The simple, rather naive style used by illustrator Lauren Child for Charlie and Lola is usually considered most appropriate for children, and if used on adult products would insinuate that the consumer was juvenile. However there are comic styles that have been developed specifically for adults. Photography can also employ styles to add symbolic meaning, such as the mimicry of hand-tinting, to express nostalgia or tradition. Understanding the meaning your image conveys is vital when choosing a style for your brand.

**Top, left:** Lauren Child's distinctive illustrations combine drawing, photography and collage to create a style that has a childlike, naive quality, perfect for its intended readership of 3 to 7-year-olds.

**Above, left:** Double Fine Productions, an American videogame company, employs a quirky, eccentric but sophisticated cartoon style for its brand, appealing to adults rather than children.

**Above:** The retro shoe brand Swedish Hasbeens have employed a hand-tinted effect for this promotional image, to reflect their vintage brand personality.

# Milka chocolate

The first Milka chocolate bar, with its distinctive cow, was launched in Switzerland in 1901. Since then the cow has become as much an icon of the brand as the distinctive lilac colour of the packaging.

## The icon

Since being domesticated in the early Neolithic Age, cattle have played a unique role in the development of the human race, having provided us with food, leather and labour for thousands of years. The dairy cow has particular significance, as the provider of one of our simplest, purest and most useful products – milk.

In this illustration, created for the rebrand of Milka in 2000 by Landor Associates in Hamburg, a Montbéliard cow (known for its quality milk) has been depicted in a semi-realistic style, with its horns, udders and nose highlighted, and the facial details and texture of its coat and tail clearly depicted. The usually brown-and-white Montbéliard, though, has become lilac. She also sports a bell around her neck, used by dairy farmers in the Alps to locate their animals.

## The meadow

Although lilac in the illustration, the lush Alpine meadow that the cow stands in symbolizes the fresh grass from which the cow will create the milk used to make Milka chocolate.

## The mountains

Jörg Willich, Landor's Creative Director in Hamburg, who led the rebrand in 2000, highlighted the significance of the mountains, explaining that the Alps symbolize nature, an unspoilt environment and purity, signifying the Swiss heritage of the brand and the wholesomeness of the product.

## The use of colour

During the rebrand the creative team identified the colour lilac as the most significant element in communicating the brand's heritage. This colour has been associated with the Milka brand from the start, although over the 100 years of the brand's history the shade has changed, finding its final tone in 1988. The impact of this symbolic brand language was revealed a few years ago in an art competition in southern Germany; when 40,000 children were asked to draw a picture of a cow, almost a third of them painted it lilac!

## The typeface

The Milka typeface is as unique to the brand as the lilac colour, and has been associated with the product since 1909. The white, soft, curved script has the appearance of being created from a puddle of spilt Alpine milk, given enhanced three-dimensional qualities by a drop shadow of darker lilac.

# NAMING BRANDS

A brand name is one of the most important elements of a brand identity, as it needs to define a unique offer, communicate effectively to a particular audience, capture a set of specific values, and look and sound good! It is therefore probably the most difficult aspect of creating a brand, and should not be undertaken lightly. The final decision always rests with the client. However, this will usually be based on a great deal of research by professionals, including designers and brand managers. Considerable attention is given to new trends and market conditions, too, as a brand must be current and relevant to be successful.

There are a number of key approaches that can be taken to help ensure a successful brand-naming strategy:

**1. Descriptive.** This is the simplest naming strategy, using words that define or highlight key aspects of a product or service, such as Royal Mail or American Airlines.

**2. Acronyms.** Using the first letter of each word of a name, such as KFC (Kentucky Fried Chicken). A similar approach is to use syllabic abbreviations, an abbreviation formed from (usually) initial syllables of several words, such as 'FedEx', which is an abbreviation of the name of the company's original air division, Federal Express, used from 1973 until 2000.

**3. Fanciful.** This approach uses words that either look or sound good but do not necessarily have any relationship to the product or service that the brand represents, such as the telecommunications brands Orange and O2.

**4. Neologisms, or Make it up!** Creating a word that reflects the values or unique nature of a brand but has no actual traditional meaning. The brand Gü was created by James Averdieck, given its unique brand identity by design agency Big Fish. Pronounced 'goo', it was created to evoke the gooey, oozing nature of their puddings.

**Left, top:** Dragon Rouge identified the need to create a strong cultural link for Danone's sub-brand of Greek-style yogurt. The name Oykos was perhaps a derivation of the Greek word *oikos*, meaning house, family or household.

**Left:** For Divvy's brand creation, IDEO applied the slang term divvy, meaning 'to divide evenly or to share' – highly appropriate for this bike-share system providing Chicagoans with eco-friendly transport.

**5. Onomatopoeia.** Using a word to imitate or suggest the sound associated with a product can be a very effective way to develop a unique name. Many highly successful brands have employed this deliberately. In the case of Schweppes it was a happy accident. Johann Jacob Schweppe, an amateur scientist and entrepreneur who founded the Schweppes Company, was blessed with a delightfully onomatopoeic name that chimes with the 'hiss' as you prise the cap from the bottle of carbonated drink.

**6. Use of another language.** Researching words in different languages can add another dimension to your brand's appeal, although you must be careful to research all interpretations. The Gü team played with the word 'gout', which means 'taste' in French. However, in English 'gout' means an unsightly disease often associated with over indulgence – not such a great name for a pudding.

**7. Personal identity.** This is often taken from the name of the inventor or founder of the company, for instance Disney or Cadbury.

**8. Geography.** Defining a brand in relation to its geographical location can be a way to define its cultural heritage, particularly in relation to food and beverages, such as Newcastle Brown Ale, Yorkshire Tea and Jacob's Creek wine.

Since the birth of brands in the late nineteenth century there have been some key trends in the way brand names have been created.

Traditionally many brands took the name of the founder or inventor of the product, as in the case of Kellogg's and Heinz. Then, in the 1930s, Procter and Gamble became the first company to professionalize and manage brands.

In the mid-1990s, using words that were either made up (neologisms) or fanciful became common practice, such as the name Orange, created for UK mobile phone network Hutchison Telecommunications in 1994.

Then in the late 1990s in the UK there was a trend to rebrand many traditional firms. The Post Office became Consignia, Andersen Consulting became known as Accenture, and Diageo was formed by the merger of Guinness and Grand Metropolitan. This approach had patchy success, and in some cases the companies reverted to their original name – such as Consignia, which reverted to its older name of Royal Mail.

Designed by Big Fish, the Gü brand has been highly successful since its launch in 2003. Its success is due in part to how effectively the product reflects the brand name, being truly gooey.

## Creating a mood board

1. Consider a mood or feeling you would like to explore – in this case, 'traditionally British'.

2. Using a thesaurus, look for related words that will define your mood in more detail.

3. Search for images on the Internet that express the emotion you are trying to capture.

4. Now design your board either by hand or on the computer using packages such as InDesign or Photoshop.

This mood board captures the essence of British rural life using a range of appropriate images and words. Note the various typefaces that develop this mood, and the overall layout and design.

# THE USE OF EMOTION

The key to making a brand successful is to make sure it 'speaks' to its audience. A designer must understand the consumer in detail – their lifestyle, needs and desires – before starting on the creative process, so that they can target their audience with the most appropriate message, using the right *tone of voice* (the way a brand uses language to express its personality and connect with its audience).

The designer starts with a range of words that defines the direction, followed by what is known as a mood board. Developed from images and words, these visual research tools are used extensively in the early stages of the design process as they can be shared by the design team, brand managers and clients, ensuring that the focus of the emotion is relevant and appropriate.

Mood Board

COUNTRY

*Britishness*

rustic

*Authenticity*

*Nostalgia*

warm

EARTHY

**Far left:** Loyalty to a traditional brand identity that has built up over time can create strong emotional ties for consumers. The Two Horse jeans patch has been part of the Levi's brand since 1886, a style that has changed very little.

**Left:** Brands that wish to express a nostalgic emotion may therefore apply typefaces that have a historical feel, along with traditional illustration styles, as with Crabtree & Evelyn's use of a wood-engraved illustration in this older version of their logo.

Once the approach has been determined using a mood board, exploring colours, images and styles of typography can also underline the emotional feel of a brand. The choice of colour is usually a very personal one, although as already discussed, certain colours come with established connotations, and any choice will need to be appropriate for both the product and the intended consumer. Various colour theories, and the trusty colour wheel, can be helpful, but ultimately decisions will be based on the feel and impact the design needs to have.

The appropriate use of imagery can also help reinforce your message. For instance, developing a brand that expresses nostalgia could use a woodblock illustration alongside traditional typefaces similar to those found on old shop signage. Developing a successful brand identity also demands an understanding of how fonts convey emotion and meaning, which is as important as knowing font metrics. Each typeface has its own distinct character, like the roles within a drama. One may perform the 'drama queen', theatrical and flamboyant, demanding attention (Chopin Script); another may play the 'general' – strong, assertive and powerful (Times New Roman), while the 'professor' will convey a trustworthy and impressive command of advanced science and technology (Bank Gothic).

**Top:** *The Times* newspaper was the originator of the Times New Roman typeface developed by Stanley Morison. A letterform that could be characterized as a 'General', this typeface commands the viewer.

**Above:** The typeface used by Agent Provocateur could be described as a 'drama queen' – theatrical and flamboyant, demanding attention.

**Left:** 'Professor' brands, although perhaps a little geeky, do impress us with their command of science and technology.

# BRAND PERSONALITY

Brand personality theory was originally developed by Stephen King of communication agency J. Walter Thompson, who recommended assigning human personality traits to a brand to achieve differentiation. This has become essential practice in the advertising toolkit and has evolved into more complex personality forms, known as brand archetypes. These include the hero, the explorer, the villain and the underdog. Think about what archetypes resonate for you in particular brands. (See also Aaker's 'Dimensions of brand personality' framework, on page 14.)

# TARGET MARKETING AND BRAND POSITIONING

A brand strategy must also define a brand's market position, and the type of consumer who will purchase it. Target marketing is a method used by companies to identify their intended customers in detail so that the design team have an understanding of their buying decisions, based on income and taste. This research may consist of drawing up a broad view of the consumer, or more in-depth research may be undertaken, analyzing real people in their homes and lives.

Research carried out by planners and marketers will break the overall target market down into manageable segments. These should not just be convenient to the company, but ones that allow the brand to communicate to one specific target market. This will be determined by:

- The type of product or service defined by the brand

- The target audience or consumer who would buy that product or service

- The other competitor brands within the market

- The brand's aspirations

- The environment the brand will be marketed in, i.e. the type of store, street, city

The team will then thoroughly analyze the findings to determine the appropriate market position for the brand.

**Left:** Giving visual clues as to the market position of a brand helps to communicate effectively to its target consumer. Strong, bold sans-serif fonts and primary colours have become associated with value brands.

**Above:** Mid-range brands often develop more complex communication systems, using a wider range of visual imagery, colours and typography.

# Market positioning and visual language

Just as specific languages for certain product categories have developed within the design of brands, packaging and other graphic communication, the market position of a product or service is also communicated through the style of type, use of colour, layout and imagery. These techniques are termed 'visual cues'; often difficult to discern, they nevertheless determine how a consumer appreciates the worth or value of a product. Broadly the visual languages can be defined in the following ways:

### Budget/cheap and cheerful/value for money

Simple, strong, often capital letterforms; one-colour backgrounds (often white); strong colour statements, often using primary tones; very little imagery or illustration; basic packaging.

### Mid-range/affordable quality

More decorative typography; a wider range of colours and tones, with full-colour illustrations and photographs; quality packaging.

### Luxury/exclusive/upmarket

Stylish, often very simple typography using wide kerning; limited colour palette; stylized illustrations and photography; luxury packaging using high-quality materials.

Conversely, upmarket brands such as Harvey Nichols revert back to simplicity. The design of luxury brands often employs a clean, minimalist, uncluttered style.

# Niche marketing

This term describes a way of classifying products and services into distinct segments, or niches, of the market. Brands can be organized by price, demographic or purpose. Products that target the widest demographic are often those that are sold at a lower price and are known as mainstream. The narrower or smaller the niche the brand occupies (targeting specific or specialized needs, tastes or demographic), the higher the perceived value and therefore the price.

A brand strategy will need to consider how to develop clear brand drivers. They may consider a new, or specific need that the product aims to meet – such as prestige, practicality, value, luxury or sustainability – in order to develop the brand within an existing market, or possibly within a whole new niche.

Research is fundamental to finding the illusive niche, and involves the exploration of several areas:

- **The existing brandscape.** Just as we inhabit a natural landscape, brands are said to live within a 'brandscape' of competitor brands. The first stage of research is to develop a visual analysis of the brands within the niche market being considered. This can be done in relation to price (with the lowest price on the left of the diagram, and the highest on the right), perception or category.

- **Visual analysis.** Using the same diagram, analysis can also be carried out on the perceived value given to a brand through its design by using a brand analysis exercise, as described in the Visual Audit section on page 115.

- **Demographic characteristics.** This will include research into the age, gender and social class of the target consumer.

- **Lifestyle analysis.** This defines the consumer in more detail, and will include all aspects of their lives including their family situation, where they live, how much they earn, the other brands they buy, what car they drive, the places they go on holiday, restaurants they eat at, TV programmes they watch, books and magazines they read, and how they relax.

- **Lifestyle conclusions.** From gaining an understanding of the consumer, the analysis will be clarified to understand the needs, desires and aspirations of the target market to develop a clear set of aims for the brand strategy.

- **Trend forecasting.** Researching the social or economic factors influencing consumer demand can help to define a unique niche for a new product or service.

Final analysis and triangulation of the findings will define the brand's USP, providing the design team with an accurate idea of why the target consumer would wish to buy the brand. The USP will also help to define the aesthetic 'feel', which will enable the brand to provide stiff competition to the other brands within its niche market.

# BRAND REVOLUTIONS

Within certain product categories, such as chocolate or toothpaste, distinct 'product languages' – or systems of colours, type styles and symbols – have developed. When creating a new brand a design team will undertake extensive research to explore the existing language used by the competitors in order to define the appropriate use of these elements. However, although this is a tried and tested strategy, it will create a 'safe' design outcome that may not give the new brand strong shelf impact.

In the last few years, however, there has been a revolution as some brands have rebelled against tradition. This can be a risky strategy, and will only be undertaken by the bravest of brand managers, but in some cases it has been highly effective, as in the case of Tango and Vanish.

Traditionally, the product language of soft drinks has referenced either the refreshing fruity qualities of the product, or used images that appeal to children. In 1987 UK drinks company Britvic bought the fizzy orange Tango brand from the Beecham Group, who had owned it since the late 1950s. Over the following few years the packaging was redesigned twice, using the traditional product language of orange and oranges. In 1992 the packaging changed again, but this time the designers were to revolutionize the soft drink

market by using black as the dominant background colour. This colour had traditionally belonged to the product language of alcohol packaging, and so it had always been almost taboo to use it on products targeted at children. Tango had, however, decided to reposition the brand, targeting the teen market, and the use of black gave the product a bold and daring new personality. Along with memorable, bizarre, humorous and often postmodern advertising, featuring the strapline, 'You know when you've been Tango'd', the brand has become as well-known today for its marketing campaigns as for the actual drink.

Known for its stain-removing qualities, Vanish (part of the Reckitt Benckiser group) is another brand rebel. The washing powder/fabric-care market had traditionally employed white as the predominant colour on packaging, with highlights of blue, red and green. With its strapline 'Trust Pink, Forget Stains' Vanish introduced a new vibrant colour, revolutionizing the product category and energizing the supermarket shelf.

**Right:** Tango repositioned their brand from one targeted at children to one that appealed instead to the teen market. The use of black endows the product with a bold and daring personality.

**Far, right:** With its strapline 'Trust Pink, Forget Stains', Vanish introduced a bright new colour to a supermarket shelf that had traditionally been based on white.

# CULTURAL BRANDING

The Pret a Manger sandwich chain has enjoyed great success in the UK, where its French name alludes to Continental eating. This approach has helped the brand develop a stylish and desirable presence on the high street.

As our commoditized world becomes ever more dependent on the economies of all nations, branding as a means to communicate value and market products and services effectively has also become a global discipline. As a consequence many of the larger design agencies have spread their business globally; Interbrand, for example, operates 34 consultancies in Europe, Asia, the Pacific, Africa and the Americas.

As designers, however, we are most familiar with our own visual language, just as we are with our own native spoken language. Different cultures, though, use very different visual languages – sometimes so different that we have no idea what is being communicated to us. Therefore designing for other cultures can be like learning a foreign language; it is not just a matter of grammar – you also have to understand the nuances and the etiquette. In the advertising industry there has also been a significant shift away from the use of words in advertising, giving rise to an increase in the number of 'global' ads that work across more than one country and culture.

The visual language of a country will be affected by many factors, including the history, geography, climate, culture and, in countries where religion is an integral part of everyday life, the customs and rules that accompany it.

As with many of the design issues explored in this book, there is a very effective process that will enable a non-native designer to tackle designing for another culture. The key to a successful result, however, is to involve an educated 'cultural advisor' – someone from the culture being explored who understands its design aesthetics, and who will be able to determine whether something is effective rather than offensive.

## Designing for other cultures

When designing for other cultures consider the following checklist:

- How different is the culture from your own personal culture?
- Where will you look for research? Luckily, many of us live in multicultural societies, where there are many small specialist shops or supermarkets that import foodstuffs for homesick nationals, direct from the parent country. These can be an invaluable resource for exploring the branded packaging of a particular country.
- Do you know anyone from this country? They may be able to act as your cultural advisor, helping with any language translation and providing crucial background research.
- What is the general geography, history, climate, population, language, religion, etc. of the country?
- What is the range of retail environments – chain stores, supermarkets, online retailing, small family-owned shops?
- Who is the consumer? Who does the shopping? This will involve gender roles. Do those who live in the cities have the same shopping habits as those who live in rural areas?
- What is the lifestyle of the consumer? What are their needs, desires and aspirations?
- How are their brands designed? Can you discern the culture in the design of the graphics and other visual communication?
- When considering food brands, the culture of food will also need to be explored. What are the national dishes? How and when are they eaten, and by whom?

The following procedures will also be useful:

- Detailed analysis of the brands and other visual communication. The brand analysis procedure (see Visual Audit on page 115) can be used to determine the meaning behind the aesthetics.
- Design direction and conclusion. Compile your findings to create a design direction or brand strategy, determining how they will have an effect on the visual language to be used.
- Visual direction. Using images to guide the creative process will ensure that the appropriate aesthetics are used in the final design. Ensure that this includes type references, colour choices, appropriate imagery and any other relevant inspiration.

## Language considerations

The Pret a Manger chain has been extremely successful in the UK, where the name ('Ready to Eat') has fairly neutral connotations. The use of a French phrase may even allude rather positively to the renowned cuisine of that country, tying in neatly with the stylish, upmarket presence that the brand has cultivated. However, in a French context the name may risk hinting at something more downmarket – perhaps even fast-food.

The English language has borrowed so many phrases from other languages over the centuries that sometimes we feel we have a good understanding of what certain words or phrases mean, but you should never assume you know something until you have proved it to be true!

## TIPS & TRICKS

There are now many forums on the Internet that discuss cultural aesthetics, where student designers can undertake research and ask for feedback. It is worth taking the time to search them out, as they can be invaluable. If you are really lucky they may even do some of the groundwork research for you. The following are a small selection:

www.creativeroots.org
twitter.com/creativeroots
www.australiaproject.com/reference.html
www.designmadeingermany.de/
www.packagingoftheworld.com

# REBRANDING

## What is rebranding?

Rebranding is the creation of a new name, term, symbol, design – or a combination of any or all of these – for an established brand, with the intention of developing a differentiated (new) position in the minds of consumers and competitors.

## Why rebrand?

The challenge for all branded products or services, from technology companies to airlines, is to keep up with the demand from customers to constantly improve their offer and deliver improved service. Brands must therefore battle their competitors to demonstrate that they are continually enhancing both their products and services.

As a company communicates and is perceived through its identity, it is vital that their brand or brands are regularly reviewed to ensure they continue to reflect the current values of the company. If not, then the product or service needs to be rebranded, either to reflect a new company strategy, new products or changes in consumer focus, or in response to changing social or cultural trends.

## The rebranding design process

A successful rebranding should be part of a new overall brand strategy for a product or service. This may involve radical changes to the brand's logo, brand name, image, marketing strategy and advertising themes, typically aimed at repositioning the brand.

### Research

- **Brand history.** Find out as much as you can about your brand. When was it first produced? By whom? For whom? Where was it sold?

- **Brand analysis history.** How has the brand changed through time? Create a visual timeline with any images you can find of the brand, along with the dates of the design.

- **Market analysis.** How is the brand positioned currently? Who is the consumer? What is the market? What do people think of the brand? (You can ask them!)

- **Brand visual analysis.** Deconstruct each element of the current design to identify the graphic communication tools used, such as colour, font, design of logo, style. What are the strengths and weaknesses of the current design?

Now bring together all the findings of your research to define the issues that the current brand is suffering from.

## Strategy

You can now start to consider how you might rebrand, through repositioning and redesigning the identity to help it communicate more effectively to its consumers. The following questions may help by giving your strategy a direction:

- Could the brand be targeted at a new consumer?

- Could the brand be targeted at a new market, for example, repositioned as a luxury or everyday essential product or service?

- Could the brand be recreated with an updated name? (This is not absolutely necessary, but if the name is completely wrong then this could be a consideration.)

- Could a new strapline aid in the brand communication?

## Conclusions

In addition to your research findings, the answers to these questions will help you develop a rebranding strategy to direct and guide the creative process:

- Who is your chosen consumer?

- Why would they use the service or buy the products they sell?

- What tone of voice/personality will your new refreshed brand have?

- Where will you position it in the market?

- Who will be its main brand competition, and how will you make yours stand out from the crowd?

- What will be the brand's new USP?

Commissioning designers to refresh or rebrand a product or service is more common than developing a completely new brand, so this is an important skill to learn and develop.

# Lucozade

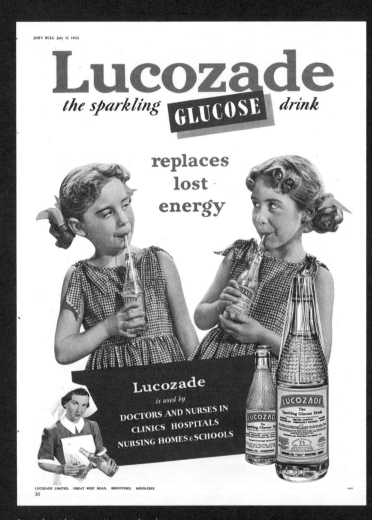

Luozade, with its promise to replace lost energy, was originally sold in large glass bottles with a yellow cellophane wrap packaging design that did not change significantly until the 1980s.

Lucozade was first produced in the UK in 1927 as Glucozade, by a Newcastle chemist, who had experimented to produce a source of energy for those suffering from minor illnesses. With its refreshing taste, golden colour and specialist glucose syrup it was successful, and soon became available throughout the country.

By 1929 the drink had been rebranded as Lucozade, with its strapline defining its USP – 'Lucozade aids recovery.' The product was sold in large glass bottles with a yellow cellophane wrap packaging design that did not change significantly for another 50 years.

During the 1980s markets began to respond to a new consumer desire to become healthier and fitter; this was the era of the headbanded jogger, and brands like Nike were on the ascendant, producing new stylish sports products for ordinary people. This new sports and fitness market provided the perfect opportunity to reposition Lucozade, shifting its reputation from a product geared towards convalescents to an energy drink, or 'pick me up', designed for the fit and healthy. Olympic decathlete Daley Thompson was recruited to advertise the rebranded product and the glass bottles were replaced with plastic.

In 1990 the Lucozade brand diversified further with the launch of Lucozade Sport, a range of isotonic sports drinks. With Lucozade Sport the brand's values were brought closer to those of real sportsmen, the brand promising to 'get to your thirst, fast'. Lucozade Sport was in fact the first brand to launch with a sports sponsorship deal, namely with British Athletics and the FA Carling Premiership, and the brand continues to be endorsed by some of Britain's leading athletes including Michael Owen and Jonny Wilkinson.

t was in 1996, however, that the brand underwent
ts greatest repositioning, reconsidering its USP
vith a massive relaunch of Lucozade Energy.
This included the introduction of the curvy bottle
– its ergonomic shape and light-weight plastic
aiming to promote the brand as an aid to
sports-focused people — as well as the new
Lucozade Energy logo and advertising.

Lucozade Sport Hydro Active further defined the
target market. Launched in 2003, its design and
communication positioned it as a fitness water
for people who exercise or go to the gym. This
approach continued the tradition of Lucozade
Sport by creating a new sector in tune with
changes in lifestyles and reflecting the
development of sport and physical activity in
modern society.

These two distinctive bottle designs demonstrate how far the
Lucozade brand has come from its original target consumer,
packaging design, structure and brand – a great example of a
evolutionary approach to rebranding.

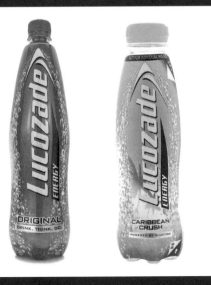

# TREND FORECASTING AND ANALYSIS

Trend forecasting, or future forecasting, is a
research methodology that studies changes in
society. These can include technological change,
fashion, social ethics and consumer behaviour.
Often this can be statistical information or market
analysis that is then studied in an attempt to spot a
pattern or trend.

However, in the early 1990s a new breed of trend
analysts started to define an innovative future
forecasting methodology, known as 'coolhunting'.
Working mainly within the area of fashion, the
ability of coolhunters, or trend spotters, to uncover
or predict new cultural trends has become
increasingly important to all fields of design. And
the rise of blogging has enabled many coolhunters
to provide almost minute-by-minute updates of
their observations.

There are companies that also offer this service,
often to global corporations. These agencies
conduct in-depth research and compile this into
reports that define trends and emerging or
declining markets. Reports are then bought by
interested parties, including design agencies. This
type of research is invaluable to brand managers
and designers during the development of
innovative creative strategies.

# BRAND FAILURES

This book is focused on how to design successful brands. However, it can be useful to study the history of brand failures too – to gain insights into the factors behind those failures.

## Common reasons for brand failures

There are three key points at which brands might fail: they may be a new brand development, an existing brand that has already carved a successful niche in the market, or a brand extension.

### New brand failure

An example of a new brand failure is the case of bottled water for pets. The twenty-first century has experienced an explosion in both the bottled water market and new products for pet owners who treat their animals as child substitutes, so the launch of a specialist bottled water for pets does not seem that far fetched – or so the makers of Thirsty Cat! and Thirsty Dog! must have assumed. Despite the fact that the water came in gourmet flavours to appeal to even the most fussy animal, such as Crispy Beef and Tangy Fish, the brand never caught on.

### Big brand, big mistake

It is hard to believe that a brand with the research and creative power of Coca-Cola could possibly make a big branding mistake. However, in the 1970s and early 80s, Coke faced stiff competition from a range of other soft drink producers. To retain its number one spot Coca-Cola decided to cease production of their classic cola in favour of a new recipe – New Coke – to update the brand and

connect to a new consumer. Unfortunately the public was outraged at the loss of the familiar drink, and Coca-Cola was forced to relaunch its original formula almost immediately.

### A stretch too far

Extending your brand can not only create a new market for your brand but also capture your existing consumer base. However, great caution needs to be taken in determining this new offering, as can be seen in the case of Clairol's innovation in hair care products. Launched in 1979 Clairol's Touch of Yogurt Shampoo was not a hit. The hierarchy of information on the pack placed the word 'Yogurt' in the most prominent position, which possibly lead to consumer confusion over whether you eat it or apply it to your hair.

## Why do big brands fail?

Brands like McDonald's, Disney and Heinz have managed to stay at the top across the globe for many generations. But these examples are rare. It seems that most brands that reach this type of megastatus stay at the top for around one generation at most.

Understanding the needs of your consumer is the first rule of successful branding. Unfortunately it appeared that pet owners did not see the need to buy bottled water for their animals.

Knowing why your customers buy your product over another is vital to the continuing success of a brand. Any change or rebrand must be undertaken with the greatest care to prevent alienating the existing consumer base.

There are several key reasons why big brands typically fail:

- **Brand ego**. Brands can overestimate their importance to their consumers and to the market.

- **Brand amnesia**. Over time, companies can forget who they are and what they stand for.

- **Brand megalomania**. If a brand overestimates its power it may overstretch its reach across as many services, products and consumers as possible.

- **Brand fatigue**. Over time companies may become bored of their brands, or forget that they need regular attention. Brands then become dated, and lose their edge.

- **Brand deception**. Via the media and pressure groups customers are now able to subject brands to close scrutiny, and the immediacy of communication offered by the Internet gives them the power to damage or even destroy a brand that does not keep its promises.

- **Brand obsolescence**. A brand becomes irrelevant by failing to appreciate that new technology or changes in consumer habits can have a huge influence on their market share.

- **Brand anxiety**. A brand may become so concerned about its design or communication that it undergoes redesign regularly, thereby losing its sense of identity and confusing its consumers.

# BRAND ETHICS

The history of brands, as explored in Chapter 1, is long and complex. However, no society has ever witnessed the power of branding as it exists today. Brands are prevalent in every aspect of human life, from what we consume to what we wear, how we construct our personalities and lifestyles, and branding is as important to politics as it is to pop culture. Branding is no longer solely about differentiating between products; brands themselves have become cultural icons.

In the last 50 years or so this form of communication has proved to be both powerful and lucrative, with the biggest brands earning similar profits to the gross national product of some countries. Therefore the ultimate objectives in branding have become the domination of the market, and the elimination of competitors. In this ruthless world competition for market share has taken priority, with consideration of moral issues being the last concern for many. It seems that the more successful a brand is, the more likely its branding strategy is to be ethically questionable. Brand advertising reflects this clearly, with 99 per cent of messages consisting of 'Consume more' or 'Shop 'til you drop!' So are consumers happy with the status quo? Or is there a sense that there should be another approach?

Canadian author Naomi Klein's book *No Logo* (1999) is considered by many to have been the genesis of the anti-globalization, anti-branding movement. Klein explored the struggle taking place at the time between corporate power and anti-corporative activists, as well as the various cultural movements that had sprung up, including *Adbusters* magazine and the culture-jamming movement, and Reclaim the Streets. She also discussed the McLibel trial that had had a devastating effect on the reputation of McDonald's.

In this, the longest-running English trial in history, two environmental activists from London (Helen Steel and Dave Morris), who had written a pamphlet making claims against McDonald's, were taken to court by the company to face a charge of libel. Although Steel and Morris were found guilty of libel on several counts, the judge also ruled that many of their claims (relating to issues such as misleading advertising, cruelty to animals, low wages and high-fat foods) were true.

Klein was not the only voice questioning consumer culture at this time. Other critics of modern society and the new world order included the linguist and philosopher Noam Chomsky, and the sociologist Anthony Giddens, who published his book *Runaway World* in 1999 and edited *On the Edge* in 2001. Both titles explored the impact of contemporary capitalism on our daily lives and questioned its compatibility with social cohesion and justice.

So how can ethics become a driver within a brand strategy, and what are the ethical issues that need to be considered by designers? These are not always easy to define. It is often difficult to distinguish between ethics and legality, and values can vary between individuals, organizations and cultures – they can also change over time. So why would a brand wish to involve itself in these murky waters? Ultimately it is because an ethical brand strategy can significantly enhance a firm's reputation, while unethical behaviour can severely damage or even destroy a brand's carefully created but intangible assets, as evidenced by high-profile corporate scandals.

An example of this was the Nestlé's infant-formula scandal in the 1970s and 80s. The World Health Organization had found that children in developing countries being fed Nestlé's infant formula had mortality rates five to ten times higher than those fed breast milk. A promotional campaign had been set up by the company to distribute the formula to poor mothers for free, using uniformed nurses. Lactating mothers were encouraged to use the powdered milk long enough for their own milk to dry up. They then became entirely dependent on the formula, which many could not afford. The result was that children received an insufficient quantity of milk. The powdered formula also required clean water, which was not accessible in most of the areas targeted by the campaign.

So are brands now more enlightened, ethical and respectful of consumers' needs and sensitivities? Consumer advocate Martin Lindstrom is championing a new way of addressing the needs of consumers. In his latest book *Brandwashed: Tricks Companies Use to Manipulate Our Minds and Persuade Us to Buy*, he exposes the extent of the psychological tricks companies have devised to get us to part with our money. Through his publications and website he is leading a campaign to demonstrate how ethics can become a driver within brand strategy, and which issues need to be considered by companies and designers. 'The New Ethical Guideline for Companies of the Social Media Age' was developed based on research and votes from more than 2,000 consumers who identified the ten ethical rules they would most like companies to follow:

home            share
hope            change
here            sheltered
have            wish
hideaway    children

Whether on the high street, or via a mailshot or emotive poster, charities have become experts at encouraging us to give, with a considerable amount of this success due to great branding and strong communication.

This identity, created for Shelter by Johnson Banks, has enabled the charity to reposition itself in the minds of the public and attract new and more powerful corporate supporters.

- Don't do to kids what you wouldn't do to your own. Don't do to consumers what you wouldn't do to your closest friends and family members.

- Secure an 'ethical' sign-off from your target group each time a campaign, new product or service is about to be launched in the market. Develop your own independent consumer panel (a representative target audience) and disclose the perception of the product, as well as the reality. Let the consumers make the final call.

- Always align perception with reality. Your talents might lie in brilliantly creating convincing perceptions, but how do they stack up against the reality? If there's a mismatch, either one must be adjusted in order for them to be in sync.

- Be 100 per cent transparent. Nothing less. The consumer must know what you know about them and they must be told exactly how you intend to use the information. If they don't like what they see, they need a fair and easy way to opt out.

- Almost any product or service has a downside – don't hide the negatives. Tell it as it is. Be open and frank, and communicate it in a simple way.

- All your endorsements and testimonials must be real – don't fake them.

- Does your product have a built-in expiration date? If so, be open about it and communicate it in a visible, clear and easily understood manner.

- Avoid fuelling peer pressure among kids.

- Be open and transparent about the environmental impact of your brand (including its carbon footprint and sustainability factors).

- Do not hide or over-complicate your legal obligations to be placed in your ads or on your packs. These should be treated just like any other commercial message on your pack, using simple, easy-to-understand language.

As graphic designers we create a bridge between information and understanding. Much of the world we experience around us – the spaces we inhabit, the products we consume, the media that comes to us through our televisions and computers – has been designed. In this period of unprecedented environmental and social change, we have a great responsibility – we can continue to invent deceptions that encourage unsustainable consumption, or we can help to find solutions to society's ills.

Most designers know from early on in their careers who they aspire to design for, and who they would prefer to avoid. For example, would you create campaign posters for a far-right political party, a brand for a fashion label that employs child labour in a developing nation, or a website for an arms dealer? The decision should lie with the individual, depending on his or her own morals and belief system. In the case of freelance designer Mickey Gibbons it was with the campaign for a major cigarettes brand, who were going to roll out across several developing countries, that he drew his ethical line in the sand:

> I felt uncomfortable being asked to encourage young African and Asian men and women to smoke cigarettes based upon an idealised decades-old image of the American dream.

Bluemarlin are a great example of an agency that has offered its branding skills and expertise to a truly worthy cause, through their design for Forces Sauces. Combining entrepreneurial energy and charitable spirit, the premium sauces range makes it simple for the British public to give back to those who have served.

I turned the job down ... I was never asked to work with them again. But I was happier in the knowledge that I would be putting my skills as a designer to better uses that did not result in the harm or even death of my chosen audience. Even if those uses were a lot less financially rewarding.

Most designers would agree that the opportunity to work on a brand that has a strong ethical stance offers both a rewarding creative challenge and a personal 'feel good' factor. Bluemarlin London, for example, worked on the development of such a brand with Stoll, a charity that provides rehabilitative support to vulnerable and disabled ex-service men and women. The design team was commissioned to work on a range of sauces created by Bob Barrett, a veteran from the Queen's Life Guard who, along with other veterans, had begun to sell burgers at London football grounds to help raise money for the charity. The brief was to design a new brand for Forces Sauces, which donates at least 6p per bottle of sauce purchased towards supporting beneficiaries of The Royal British Legion and Stoll.

# MAKING YOUR OWN DECISION

These are difficult decisions for any professional to make. However, perhaps being a conscious designer makes one a better designer. When you need to make a difficult personal decision, be aware of what you are being asked to do, and ask yourself two simple questions:

1. Am I hurting others? We have a responsibility to design products and brands that work, but do not forget that the consumption of brands can influence the world – both its people and the environment.

2. Am I delivering an honest message? There are many examples of companies that promise to be helpful, original, organic, etc., but are they? Will your brand stand up to its promises?

If the answer is yes to the first and and no to the second, you need to consider why you want to continue working on the project.

In the same way that using a grid to lay out type on a page, or a line to define the baseline of text, is vital in successful typesetting, so there are systems and rules that are used to capture innovative ideas and ensure professional results when it comes to the branding design process.

# CHAPTER 4:
# THE DESIGN PROCESS

Many of us can often create a clear picture of the final outcome of a project immediately after being briefed. Surely, then, all we have to do is sketch it out, do a bit of computer rendering and our job is done? The problem with this sort of instinctive approach is twofold. Firstly, such outcomes are frequently knee-jerk reactions, limited to the finite number of pictures we have stored in our imaginations. Secondly, there are the real-world considerations, such as proving to your client (or tutor) that you have met the brief, in time and on budget.

A standardized design process has therefore evolved within the industry that provides the designer with the resources and framework for producing their most innovative and creative work within a reasonable timeframe. This chapter provides a general overview of this structure and its benefits; the specifics of the activities involved will then be covered in detail in subsequent chapters.

# WHY USE A DESIGN PROCESS?

In the past, the desire of companies to fix or control their image led to the development of the 'corporate identity'. However, this principle – conceived and reared in the corporate sector – has now been adopted by all sorts of organizations; today, even charities and arts institutions share the commercial ambitions of their corporate sponsors. A design practice may undertake work for a museum, gallery or publisher, and find itself immersed in any subject from art and architecture, to theatre, music, history, science, politics and literature. Likewise, designers today are highly familiar with business practice in fields such as banking, insurance, pharmaceuticals, manufacturing, retail, the automotive industry, sport and government. A graphic designer will often even be required to use their creative skills to develop separate, highly distinct and yet related identities for the same brand. In response to these demands, many design agencies have honed their design process into an almost scientific methodology. This will often be highlighted in their promotional material and on their websites, demonstrating to prospective clients the process they use to facilitate creative success.

Although the design process can be represented on paper as a clean, linear progression of steps – and tends to include broadly the same steps in each case – it is interesting to explore the creative approaches of different agencies to see how working methods can differ. For instance, some large agencies may use a set approach for each client. Devised through trial and error, this system will be designed to maximize both brand design and profit for the agency. However, other agencies may use a more flexible approach, establishing a specific procedure for each new project. Johnson Banks, a brand and identity agency, helped create the More Th>n brand (a direct insurance company)

from scratch. It showed that blue-chip brand creation did not have to be a stuffy and conservative business. The same agency also worked on the rebrand of Shelter, demonstrating that a charity could also take branding seriously; almost overnight it confirmed them as a major player in their sector.

## The client's role within the design process

Now more than ever, the design process is influenced heavily by clients, who demand profitable outcomes from the creative process. Today's businesses are highly aware of the importance of building on their brand and communication, and will therefore commission design that is on their own terms. Correspondingly, design agencies frequently seek to involve them throughout the research and creative stages, enabling them to shape the creative brief and define goals.

In some cases companies have demonstrated the importance that they place on branding and communication by creating their own in-house design agency, as in the case of the supermarket Waitrose or retailer Marks and Spencer, both in the UK. Other companies may take the approach of creating positions in-house for high-level brand managers.

Johnson Banks, the design agency that created the elegantly simple More Th>n brand, has demonstrated over the years an innovative use of design and creative processes, including asking children to draw the typefaces for the identity for Save the Children.

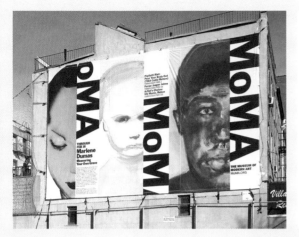

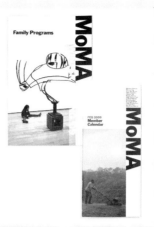

The Museum of Modern Art (MoMA) demonstrate their understanding of the importance their brand communication plays in their success, by employing their own in-house design team to produce an extensive range of promotional materials, which are based on a system for the consistent treatment of images and type designed by Pentagram.

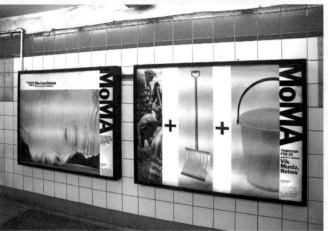

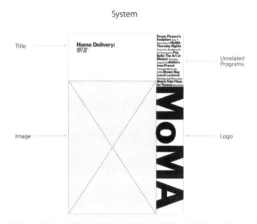

System

# HOW DOES THE DESIGN PROCESS WORK?

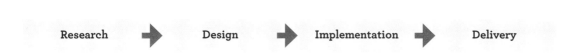

Research ➤ Design ➤ Implementation ➤ Delivery

The design process has been developed and extended considerably in the industry over the years into quite complex and detailed approaches (an expanded 13-stage model is provided on page 78), but this simple generic model gives a quick overview of the major stages undertaken by many branding agencies around the world to develop a brand identity.

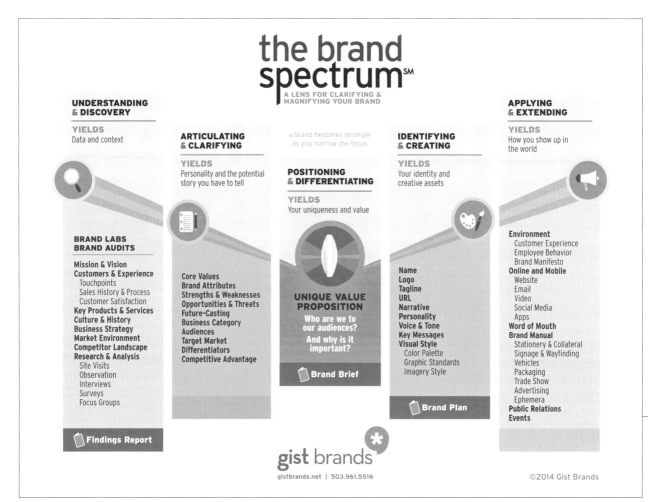

For their Virgin identity project, the challenge for the design team at Johnson Banks was how far to take the existing brand – whether to attempt wholesale revolution, or to carefully evolve the existing brand elements.

This approach not only helps organize the creative process, but also allows design agencies to demonstrate how a client's money will be spent, as well as helping to demystify what, for many, can be perceived as a magical process. When developing a brand identity it is difficult to predict how the creative process may develop, but it is essential that the identity goes through all of the key stages. It must be checked against goals, refined and questioned to ensure that the final designs will meet the original brief. The process is the same, whether creating a new brand, or facilitating a rebranding.

This four-step process can also be applied to any student design project. Its structure will help you creatively by making sure you allow adequate time and space to think, experiment and apply your imagination. It will also harness your problem-solving skills if you run out of ideas. Finally, it will ensure that you demonstrate:

- Your design decisions, which will help justify the final concept
- The depth and breadth of your research, highlighting your knowledge of current markets and practice
- Good project management skills – answering the original brief and keeping to budget
- Time management – allowing each stage of the process the necessary development to ensure a successful creative outcome

This comprehensive infographic, designed by Jason Halstead to aid his clients' appreciation of his process, articulates the way that each stage of the branding process builds through from research to the final design outcomes.

The first step was to undertake an exhaustive audit, a detailed process to define what the company stood for, both in the mind of the client and the target consumer.

From even the earliest designs, the team agreed on writing the company's name in full and as large as possible down the fuselage.

The requirements of an airline identity are myriad, and cover all shapes and sizes, from full-colour fuselage, to screenprinted catering packs, to tiny logos on travel comparison sites.

# THE STAGES OF THE DESIGN PROCESS

Once the client has commissioned an agency to work on their brief, and after the brief has been received, the senior design team will work together to structure the design process they will use to create the new brand. This next section provides a brief introduction to each of the key stages that make up this process.

## Stage 1: Analysis

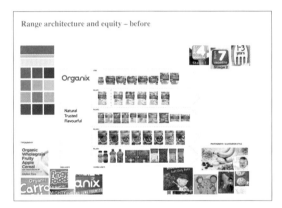

Analysis is a detailed examination and evaluation, which involves asking questions and seeking evidence. Prior to this stage, extensive consumer research will have been carried out, and the aims and methods of this are covered in Chapter 5. Chapter 6 explores product and market analysis; this includes examining both visual properties and marketing successes.

Aspects that can be subject to analysis include:

· The age and history of the brand
· The current market position
· The target market/consumer/audience
· The existing brand properties
· The overall aims of the project, timeframes/deadlines and budget

GlaxoSmithKline's 'Shopper Science Lab' is a research facility that aims to uncover the factors that determine consumer decision-making.

| | |
|---|---|
| **Stage 1** | Analysis |
| **Stage 2** | Discussion |
| **Stage 3** | Design platform |
| **Stage 4** | Briefing the designers |
| **Stage 5** | Brainstorming |
| **Stage 6** | Independent research |
| **Stage 7** | Concept development |
| **Stage 8** | Analysis of design concepts |
| **Stage 9** | Refining the final concepts |
| **Stage 10** | Client presentation |
| **Stage 11** | Finishing/prototyping the final design |
| **Stage 12** | Testing/market research/consumer reactions |
| **Stage 13** | Delivery of final artwork |

## Stage 2: Discussion

Discussion takes place in order to explore the findings of the analysis and the client needs. This helps to determine the drive, or the direction the new design needs to take. It also gives the designers the opportunity to challenge the brief.

## Stage 3: Design platform

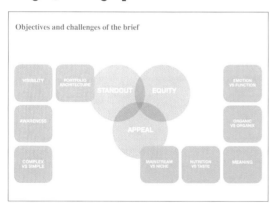

This constitutes a fuller form of brief. The senior creatives produce a summary of the analysis, as well as the direction requested by the client. This leads to a process of linking the findings of the analysis to the design strategy developed by the designers.

## Stage 4: Briefing the designers

At this stage the senior creative team present their findings to the creative team. This will cover:

- The design platform
- The analysis of and information developed on the competitors
- An analysis of the failures and successes of any previous design

## Stage 5: Brainstorming

Ideas will now be 'brainstormed', or discussed collectively, so that the designers can fine-tune their perception of the brand's identity. This approach will include:

- The brand's equity (see page 38), history and heritage
- A semantic understanding of the symbols, colour and other iconography that will be used to build up the brand's unique personality (see Chapter 2)
- The development of a project vocabulary, or words that describe the brand, personality, emotional attributes, etc.

# Stage 6: Independent research

Research will now be undertaken by the individual designers, or by the design team, exploring a wide range of sources to inform and inspire initial ideas. (The creative process employed in the creation of a brand identity is covered in detail in Chapter 6.)

# Stage 7: Concept development

This involves the creation of many different ideas, including names, straplines (slogans), brand marks and any other elements demanded by the client. This stage may be undertaken by an individual designer or by a design team. The number of ideas generated will depend on the time available and the budget allocated. Students are often surprised to discover that this can run into hundreds.

### Thumbnail sketches

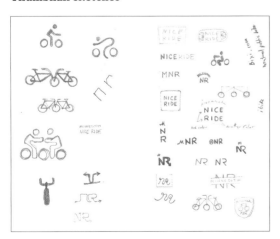

At this point the ideas are based on initial thoughts. 'Thumbnails' are small, quick and unfiltered sketches, often still drawn with pen and paper. The goal is to explore as many ideas as possible without becoming attached to any one in particular. For concept origination and development, start with 'free' sketches – a record of thoughts and potential, and a means of rationalizing and furthering ideas. These initial sketches do not need to be to scale, have the correct perspective, or be very polished, but as the idea development process progresses, there is an exponential need for accuracy in these drawings in order for a concept's potential to be assessed. The ability to try out ideas on paper at speed is valuable. In a meeting, being able to occasionally draw a solution to make a point rather than retreating to a computer can really help.

### Rough concepts

The design team then review all the sketches, testing them against the creative brief/design platform. Those that show potential are explored further, with pen and paper or on the computer.

## Stage 8: Analysis of design concepts

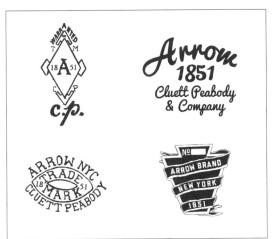

The 'rough concept' ideas are now reviewed by the design team, in light of all the research and analysis undertaken, and referencing the original brief set by the client. These concepts are reduced to a few key options, which are then offered to the client. This creative approach allows the client a chance to view the possible outcome of a project from different perspectives.

## Stage 9: Refining the final concepts

This stage ensures that the concepts chosen by the design team clearly communicate the final desired message and, therefore, meet the brief. The ideas will be further developed to show a range of creative approaches. Design teams will work to produce a range of ideas along a creative scale such as 'mild to wild' (working with ideas ranging from the understated to the outrageous) or 'evolution to revolution' (where the solution is either closely aligned with existing businesses, or creates a whole new category for itself). The design team will also show how the identity works when scaled large and small, in reverse, in black and in colour. However, these concepts are still in a raw form; more time will need to be spent refining the typography, use of colour, etc., before the finished artwork stage.

Along with the semi-finished artwork created to visualize the final designs, other presentation materials will also be created to demonstrate the chosen design solutions to the client.

## Stage 10: Client presentation

The creative director, senior designer or client handler may undertake this stage of the process, depending on the management structure, size or organization of an agency. This is the culmination of often hundreds of hours of work, as well as the opportunity to demonstrate to the client how and where their money has been spent. The outcome of this stage will define the final outcome of the project as only one concept will be chosen.

In an academic environment this stage is often mimicked by a formative crit, where tutors take the place of the client to give feedback on the quality of the final designs and their relevance to the brief.

## Stage 11: Finishing/prototyping the final design

Color versions

The concept chosen by the client (or tutor) will now undergo the final development stage, with any changes that have been discussed with the client incorporated into the final identity. All the elements of the brand identity and any other supporting design work are created to finished artwork stage.

## Stage 12: Testing/market research/ consumer reactions

This vital stage ensures that the final design achieves its most important aim – that it 'speaks' effectively to the desired audience. Small tweaks to the final design may be necessary after this phase.

Various methods are used to test the success of a final brand identity, such as consumer focus groups (see page 96). A brand identity at this stage, though, is highly sensitive and will be protected by non-disclosure agreements, created to ensure that all working on its development maintain a level of secrecy (see page 152).

## Stage 13: Delivery of final artwork

All the creative outcomes developed in response to the client's original brief are now signed off by the designers and delivered to the client.

For students this stage will take the form of a summative crit, where tutors will assess the final designs, grading them on the basis of their quality and their relevance to the original brief set.

## Beyond delivery

The responsibility of launching a brand is traditionally undertaken by the client, working together with a marketing or advertising agency. However, a design agency may be asked to produce marketing literature for the brand or, in the case of packaging, elements of launch communication such as point of sale.

Effective branding is a marathon not a sprint; it often takes years to effectively communicate the brand values and grow the consumer base. For many large brands the continuing development of an individual brand is the job of the brand manager, working from inside the parent corporation. It is their job to police the communication and marketing of the identity, involving designers when the brand needs to be refreshed or extended.

# THE DESIGN TEAM

Who is responsible for the practical creative processes involved in creating a brand depends predominantly on the size of the agency and how many designers it employs. In smaller agencies there may be a lot of overlap between the various tasks involved, which will range from working with the client to research, concept development, final artworking and making the tea. In larger agencies, teams are constructed hierarchically. A number of junior designers will be supervised by a designer, who in turn is supported by a senior designer responsible to the creative director. A senior creative may be responsible for client liaison, or in a large agency a client handler may be specifically employed to take on this role. Job titles and structures may also vary, depending on the focus of the agency or its management structures.

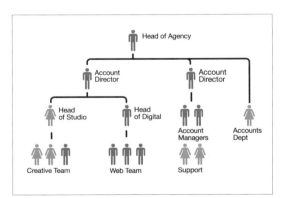

This diagram shows the typical management structure of a small to medium-sized agency, and the various roles and responsibilities within it.

Working on your own can be both lonely and frustrating, particularly when you have an uncreative day.

## The benefits of working in a team

There is a popular concept that highly creative people enjoy and benefit from working alone. Although it is true that solitude can fuel a creative mind, boost productivity (and attracts fewer distractions), it can also be counterproductive. Human beings are social animals. We are designed to mingle and work collaboratively, and have evolved to transcend challenges by sharing our experiences with others. Ultimately design is a creative challenge, and creativity requires dynamics. For instance, if you have a creative idea, how can you ensure that it is successful if you are the only one judging it? All you will have to gauge your ideas by will be your own point of view.

Creative teams, on the other hand, offer the chance to 'mind map' or brainstorm – to discuss ideas and explore far wider possibilities than are possible for an individual. Good teamwork helps us create and share ideas, and harnessing the unique creative strengths of individuals within a team can produce a final result that surpasses what any individual could produce alone. Surrounding yourself with a team of great people and remaining open to suggestions will enhance your creativity not distract it.

# THE CREATIVE PROCESS

This chapter has so far explored the practical steps that take place when creating a brand identity. This process is visible, measurable and explicit. However, there is another process vital to the quality of the final outcome; this hidden, almost magical process is known as the creative process – or the role played by the imagination. This very personal internal process reflects the individual personality of a designer and can be highly logical, emotional or instinctive.

One of the earliest models of the creative process is attributed to English social psychologist Graham Wallas, who in his 1926 book *The Art of Thought* proposed that creative thinking proceeds through four phases:

**1. Preparation** – initial work on a problem that focuses the mind and explores the scope or dimensions of the problem.

**2. Incubation** – the problem is internalized by the unconscious mind and nothing appears to be happening.

**3. Illumination** (or the 'eureka' moment) – the creative idea bursts forth from preconscious processing into conscious awareness.

**4. Verification** – the idea is consciously verified, elaborated and then applied.

Graham Wallas

Many decades later, in a 1988 essay entitled 'The Nature of Creativity as Manifest in its Testing', the American psychologist Ellis Paul Torrance pointed out that Wallas's model still forms the basis of most creative-thinking educational and training programs today. The inclusion of incubation followed by sudden illumination in this model may also help to explain why so many people outside the arts continue to view creative thinking as a mysterious, subconscious mental process that cannot be directed.

While the design process is a highly linear approach, involving clear steps arranged almost like stepping stones, the creative process is highly personal and is experienced differently by each individual designer. This makes it much more difficult to define.

One way of representing the process is via a simple four-step cyclical model that highlights how thinking evolves from uncertainty to certainty through stages of questioning and answering throughout a project.

Damien Newman, of Central Office of Design, has come up with an alternative way of respresenting the process. His 'Design Squiggle' charts the creative experience as it moves from the abstract, through the concept phase, to emerge at the final design solution.

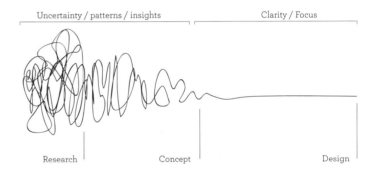

This diagram is based on Newman's licensed Design Squiggle, which maps out the creative process of design, from uncertainty to eventual clarity.

A simple four-stage cyclical representation of the creative process.

# THE DESIGN PROCESS IN THE ACADEMIC ENVIRONMENT

This chapter has explored how the design process is used within the industry, but it can also play a key role for design students completing an undergraduate programme. Firstly, learning about the processes used in the professional sphere will introduce you to the depth and breadth of research, critical thinking, analysis, creative problem-solving and graphic skill demanded by agencies. Secondly, these very processes will also provide a clear working framework for any curricular work, by breaking up the requirements of an initial brief into sequential steps that will both guide your project and support time management. Used in conjunction with an accurate personal timeplan, this will not only help you keep to deadlines, but will also allow you to allocate an appropriate amount of time to each stage of the process.

Documenting all your work, too – either through a 'process book' or a blog – will enable you to record and, later, justify any design decisions, making the final submission a much simpler process. Justifying your decisions by demonstrating the process you used to reach them proves you are both creative and a design professional.

As you gain a greater understanding of your own personal creative processes, you may find it helpful to map out a flow chart for future reference. The example on the right was developed by a group of Graphic Communication students to summarize the creative process they had used to complete a particular exercise, and demonstrates just how many steps may be involved in any personal creative journey.

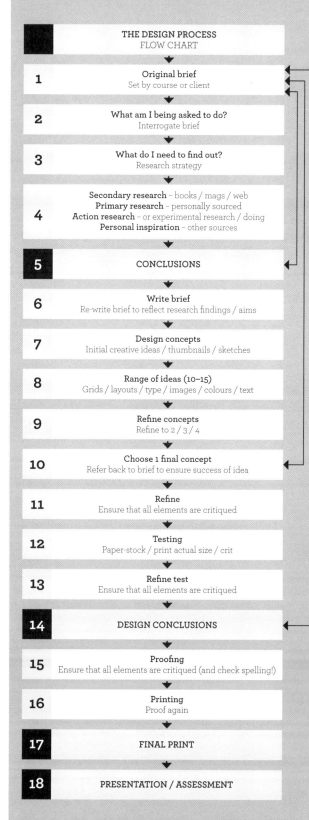

# EXERCISE

## Student exercises

The following are some examples of the kind of exercises you may be given as a student. For each brief an understanding of the design process will inform a successful outcome.

### Exercise 1: Mimicking the structure of an industry team

Groups of five students or more are set the challenge of working together on a single brand creation. Each student is given a job title that reflects the roles within an agency team: creative director, senior designer, designer and two junior designers. A member of staff then acts as the client, attending briefings and presentations. The step-by-step design process is therefore used to structure the project, both creatively and practically.

### Exercise 2: Concept creation using the 'mild to wild' or 'evolution to revolution' method

This exercise involves taking an existing brand and redesigning it for a new market. After researching the brand and its current consumers, students must identify the drive needed to make it appropriate to its new market. This will involve firstly creating a range of ideas that would move the brand a small way from its current position, followed by other concepts that would take it on a more revolutionary journey. Students can then explore their concepts further by calculating their perception of the amount of change reflected in their 'refreshed' brand.

### Exercise 3: Using blogs to document the design process

Blogs can be a very useful way for students to document their design process. However, clear rules as to how they are structured will make reviewing and assessing easier for tutors. Again, the design process can be used to support this – for example, in the form of clear titles for the different tasks undertaken. Students must also include commentary, conclusions and clear justification of their design decisions, as well as images of reference material and personal creative content.

Tips:

1. Think of categories as being like the contents page in a book. Limit the categories to around five. Readers use categories to navigate to posts they are interested in, and categories also help the writer to define their points clearly.

2. Think of tags as being like the index in a book. Tags are keywords that highlight what is being documented and are useful to speed up a reader's navigation around the blog.

Understanding the needs of individual consumers and what motivates them to make their purchasing decisions is a key area of brand research, whether those decisions are made individually or as a result of pester power!

# CHAPTER 5: RESEARCH

There are a number of key research methods used by professionals within branding agencies. This chapter explores some of these in order to give a clear picture of the depth and breadth of enquiry that needs to be undertaken, as well as to explain why adopting a strategic approach is so important. We will explore the methods used to identify and understand the type of consumer that a new brand is to target.

An explanation of how the final design direction is clarified, by analyzing this research in combination with information about the competition and the environment in which a brand will be marketed, then follows in Chapter 6.

# WHY DO WE NEED TO RESEARCH?

Research is the first, and possibly most important, stage of the design process. For contemporary brand design practitioners it plays a key role in achieving original and distinctive work. Rather than stifle creativity, research actually empowers it, and without good research findings your design work will lack focus and direction. Any time invested in research will help you to make confident design decisions, moving through the design process quickly and with conviction. In an industry context, too, clients are always reassured when they are able to see how and why designs were created.

# RESEARCH METHODS

The various research methods used to collect data can be divided into two main categories – information that is collected first-hand from a particular source (primary research) and pre-existing information (secondary research).

## Primary research methods

Primary research aims to produce new data using either direct methods such as case study interviews (see page 104) or indirect methods (such as observation). The data collected is specifically related to the question posed by the researcher and has not been previously analyzed. It is important to remember that whatever approach to research you plan to use, the methods should be applied in a systematic and disciplined way, which can be easily communicated to others. Primary research can be further divided into qualitative and quantitative research.

### Qualitative research

Qualitative research deals with subjective qualities of things. It is an exploratory research method, often using language rather than numbers to assess information, with an emphasis on the participants' interpretations of the issues being addressed. This method is used to gauge motivations, trends or reasons for actions such as purchasing decisions, and is a method traditionally used in market research.

Data is usually collected from a small number of carefully chosen cases, in an unstructured or semi-structured approach. Some of the key methods used include:

Talk to your market! Design undertaken without knowing the needs and perceptions of your target audience will lead to aesthetically driven design. It may look pretty but will it work?

Case study interviews

Individual consumer profiling

Observations

Group discussions

Internet focus groups

Being more exploratory in nature, the outcomes of this type of research are not statistical, but rather help to develop an initial understanding of a topic. This can provide valuable insights into consumer perception.

## Quantitative research

Quantitative research deals with quantity and measurement. Its focus is on numerical outcomes and statistical analysis, aiming to produce objective and reliable data. Typically, various views and opinions in a chosen sample are measured – usually consisting of a large number of randomly selected respondents. Structured data collection techniques are used, such as traditional questionnaires or, more recently, online survey sites such as SurveyMonkey, Zoomerang and Polldaddy. The outcomes collected are then usually analyzed in statistical tables, and are considered to be reliable as long as large enough numbers of respondents have been involved.

SurveyMonkey is an online research facility providing free, customizable surveys, data analysis, sample selection, bias elimination, and data representation tools.

# Research Methods

Initial Process

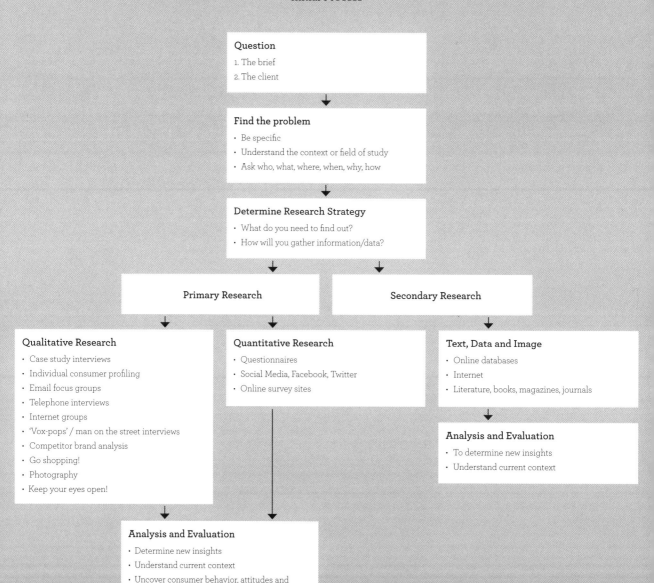

**Question**
1. The brief
2. The client

**Find the problem**
- Be specific
- Understand the context or field of study
- Ask who, what, where, when, why, how

**Determine Research Strategy**
- What do you need to find out?
- How will you gather information/data?

**Primary Research**

**Secondary Research**

**Qualitative Research**
- Case study interviews
- Individual consumer profiling
- Email focus groups
- Telephone interviews
- Internet groups
- 'Vox-pops' / man on the street interviews
- Competitor brand analysis
- Go shopping!
- Photography
- Keep your eyes open!

**Quantitative Research**
- Questionnaires
- Social Media, Facebook, Twitter
- Online survey sites

**Text, Data and Image**
- Online databases
- Internet
- Literature, books, magazines, journals

**Analysis and Evaluation**
- To determine new insights
- Understand current context

**Analysis and Evaluation**
- Determine new insights
- Understand current context
- Uncover consumer behavior, attitudes and awareness

## Secondary research

Secondary research involves collecting existing information from online sources, libraries and other archives. It often utilizes data collected by professional research groups and made available either for a fee or, in some cases, for free, and involves the collation and analysis of this data to explore the question at hand. Secondary research materials can include previous research reports, books, newspapers, magazines and journal articles, and government and NGO statistics.

This type of research is often undertaken at the beginning of a project, as it helps to determine what is already known about the current situation, and will highlight what additional knowledge is required.

As secondary research is based on the work of others it is vital that all work is credited using appropriate citation methods, such as the Oxford or Harvard system (see page 138). By doing so you not only avoid any possible issues relating to plagiarism, you also strengthen the findings and validate your conclusions.

## Combining research methods

Successful research involves collecting elements from both qualitative and quantitative sources, followed by analysis, in which the outcomes are combined and compared to gain conclusions. This approach of using two or more research methods – for example, questionnaires and observation – is sometimes known as triangulation, and engenders more confidence in the findings.

# RESEARCHING THE AUDIENCE

The modern world offers us a seemingly endless array of goods and services, as brands jostle to stand out in a densely crowded marketplace. Companies are therefore constantly seeking to make stronger emotional connections with their customers, to become irreplaceable in their lives and create long-lasting relationships. Understanding consumers' basic needs, desires and aspirations, as well as developing an appreciation of cultural issues where appropriate, is vital in determining how to achieve this.

The first step in identifying the target audience of a particular product or service is to ask a set of simple questions:

Who would need this?

Who would want this?

Why would they need it?

Who might aspire/desire to have this?

The answers to these questions will create a simple framework from which a more detailed profile will need to be developed. There are two main techniques used in the marketing industry to identify the market for a new brand, known as demographic and psychographic profiling.

A demographic profile is created to gain statistical information about a particular group within a population – for instance, middle-class, college-educated male professionals between the ages of 25 and 45 living on the East Coast of America. The aim of this type of research is to gain enough information about a typical individual within this group to be able to create a representative profile of the group as a whole. The areas generally researched are age, gender, income level, occupation, education, religious and ethnic background, and marital status. Where specific information is required more detailed market research may be commissioned to provide information on more niche markets.

A demographic profile defines a group statistically, with the outcomes of the research being generally numerical. While this information can be important for a design team, it does not necessarily inspire creativity. It is for this reason that a psychographic profile is generated. This defines group attitudes, values, interests and chosen lifestyle. These considerations will also differ from one culture to another, so market researchers will often employ a globally appropriate segmentation technique, based on Maslow's hierarchy of needs.

In his 1943 paper 'A Theory of Human Motivation', American psychologist Abraham Maslow suggested that humans have five categories of need, which can be arranged in order of importance. These categories – physiological, social, safety, love/belonging, esteem and self-actualization – are now usually represented as a pyramid, with the most fundamental (physiological) needs at the bottom, narrowing to the need for self-actualization at the apex of the triangle.

Maslow's research into human motivation was the inspiration behind advertising agency Young and Rubicam's Cross Cultural Consumer Characterization model (the 4Cs). This model characterizes people into recognizable stereotypes that reflect seven human motivations: security, control, status, individuality, freedom, survival and escape. From these core values, a set of relatively stable lifestyle profiles have been created.

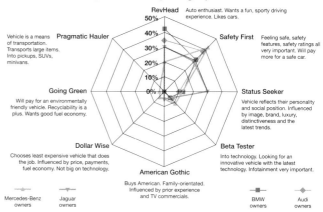

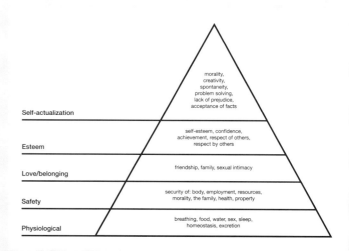

Top: Psychographics are any attributes relating to personality, values, attitudes, interests or lifestyles. This diagram shows the data collected from AutoPacific's New Vehicle Satisfaction Survey, which determines the psychographic profile of each brand and model.

Above: This diagram represents Maslow's hierarchy of needs arranged as a pyramid. Maslow used his 'categories of need' to describe the path that human motivations generally move through, starting with the most basic needs represented at the bottom, and finishing with the highest desire – self-actualization, or 'reaching one's potential' – at the top.

Opposite: Young and Rubicam's 4Cs technique is an example of a psychographic marketing research tool used to discern the number and types of people in a particular population.

# Demographics

Cross Cultural Consumer Characterization by Young and Rubicam

| SEGMENT | DESCRIPTION | BRAND CHOICE | COMMUNICATION | % POPULATION |
|---|---|---|---|---|
| **The Resigned** | Predominantly an older demographic. They have built up their value system over time, making them rigid, strict and authoritarian. Personally orientated to the past, they value survival, respect institutions and play traditional roles within society. | Brands centred on safety, economy, familiarity and expert opinion | Nostalgia focusing on simple messages | 10% |
| **The Struggler** | Living in the moment with little consideration of the future. With often limited resources and capabilities they are often perceived as disorganized and aimless. Relying on their physical skills they find achievement difficult, and are often alienated from mainstream society. | Brands offering sensation and escape | Visual impact | 8% |
| **The Mainstreamer** | Tend to be conventional, conformist, passive and risk-averse, living in the everyday world of domesticity. They focus their choices on the family rather than the individual. Represent the majority view. | Well-known and value-orientated brands | Emotionally warm, secure and reassuring | 30% |
| **The Aspirer** | Tend to be younger, materialistic and acquisitive. Concerned with status, material possessions, appearance, image and fashion, they are driven by others' perceptions of them rather than their own values. | Trendy, fun and unique brands | Status | 13% |
| **The Succeeder** | Self-confident and accomplished, they are organized and in control. They have a strong work ethic, and tend to occupy positions of responsibility in society. Goals and leadership are high on their agenda. They will seek out the best as they believe they deserve it. | Brands offering prestige and reward and brands that promise to pamper and relax | Evidence to support brand claims | 16% |
| **The Explorer** | Characterized by a desire to challenge themselves and find new frontiers. Driven by a need to discover. Young at heart, they are often the first to try out new ideas and experiences. | Brands offering new sensations, indulgence and instant effects | Difference and discovery | 9% |
| **The Reformer** | Focused on enlightenment, personal growth and freedom of thought. Intellectually driven, they pride themselves on their social awareness and tolerance. | Brands offering authenticity and harmony | Concepts and ideas | 14% |

The aim of this model is to define universal human values, regardless of culture or nationality. The various segments were created through the analysis of data initially collected from seven European countries, but which has now developed into a global database, identifying values found in cultures spread as wide as Iceland, Thailand, Lithuania and Kazakhstan.

The VALS (Values, Attitudes and Lifestyles) system is another psychographic market segmentation method, again inspired by the work of Maslow. Created by Arnold Mitchell and his colleagues at SRI International in 1978, this is also used to discern the number and types of people in a particular population.

Since the development of these lead methods, many design companies and agencies have also sought to create their own more detailed profiling systems, enabling them to delve even deeper into people's motivations and buying habits. Key to these processes is turning broad statistical data into a profile of someone you could 'get to know' – the aim being to develop a 'language' that allows a brand to 'speak' to them clearly and appropriately.

## Focus groups

Focus groups explore the perceptions, opinions and beliefs of a group of people towards an idea, product, service, package or brand. These groups of people are chosen according to their demographics or buying habits. This type of qualitative research uses trigger questions in an interactive, unstructured group setting that encourages free discussion between participants, and is usually conducted at the early stages of the development of a product or brand, to gather insights into any potential opportunities or problems with the design or the overall idea. Focus groups will highlight relationships between consumers and existing brands, explore emerging trends, gain insights into purchasing decisions and enable a new product to be tested before being released to the public.

Design agencies are seeking out a new type of focus group, made up of 'extreme consumers' – those people whose needs go far beyond the average user. Such consumers offer richer insights as they are the ones for whom the performance of a product matters most.

## Un-focus groups

Unlike focus groups, where the participants are the likely users of a product or service, an 'un-focus' group features participants who are chosen almost randomly. This method typically employs an interviewer to conduct group interviews with participants who are very different, in order to get a broader range of opinions and feedback about a product. Participants may be selected because they are an unlikely user of a product, have no use for it, dislike it, or because they have a vested interest in it or are considered extreme users (at either end of the spectrum).

The un-focus group is often used at the end of the design stage, after standard focus groups have been conducted. The broader range of views can often help tease out any problems inherent in a design, although since these are often the views of non-users of the product, researchers may find the respondents unable to define accurately what is needed to solve the problem.

# Touchpoint analysis

Key to improving brand loyalty is an appreciation of the emotions evoked by a customer's contact with a brand. Companies must ensure that all these points of interaction (touchpoints) are monitored so that the consumer experience is as fulfilling as possible. Brand value is known to be built through a series of positive experiences, and maintained by consistently meeting the needs and expectations of the customer, from pre-purchase considerations to post-purchase evaluation.

To appreciate fully how a consumer experiences a brand, research can be undertaken to engage with their emotional journey. This is known as touchpoint analysis, and it divides touchpoints into three distinct areas of consumer contact:

1. Pre-purchase (marketing, advertising)

2. Purchase

3. Post-purchase (product use, after-sales care)

A touchpoint wheel is a visual framework that summarizes all the points of interaction with a brand during which a customer may be influenced, directly or indirectly, and this can assist designers and their research subjects in evaluating the consumer journey.

Touchpoint analysis can be applied to both products and services, and it is used to inform strategy and to plan advertising campaigns. It gives the opportunity to delve deep into the consumer's experience to learn more about their relationship with the brand.

This example of a touchpoint diagram – created for Tony's Chocolonely's chocolate company – illustrates the three stages of a customer's brand experience journey, from pre-purchase through purchase to post purchase.

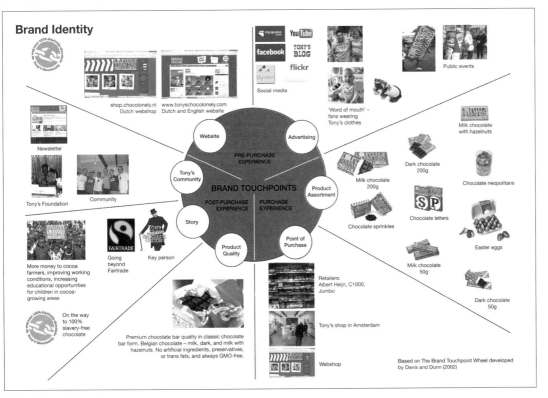

Some of the key questions asked will include:

- How well does the experience measure up to the customer's needs and expectations?
- Does each customer interaction live up to the experience that the brand is trying to deliver?
- Does the brand deliver a more consistent and relevant experience than its main competitor(s)?
- Which interactions are the most powerful in creating customer loyalty?

The outcomes of this type of research can result in an all-round improvement in the brand experience, better value for the consumer and increased brand loyalty.

# THE USE OF SOCIAL MEDIA IN RESEARCH

In recent years there has been a marked increase in the use of social media, and a resulting growth in consumer conversations relating to brands taking place on the Internet.

With so much being discussed about brands online by their customers, and so much information readily available, new research approaches are needed to make sense of it all. There is an evolving demand for systems to analyze social media data so as to be able to develop new communication strategies, and companies are increasingly investing in advanced social media monitoring tools such as Brandwatch to help them navigate this new landscape.

Brandwatch is a social media monitoring and analytics tool that permits the collection of social media metrics, transforming them into actionable data to maximize a brand's online presence.

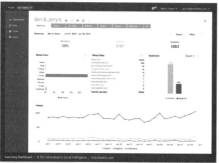

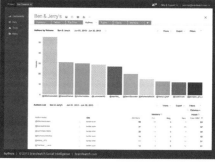

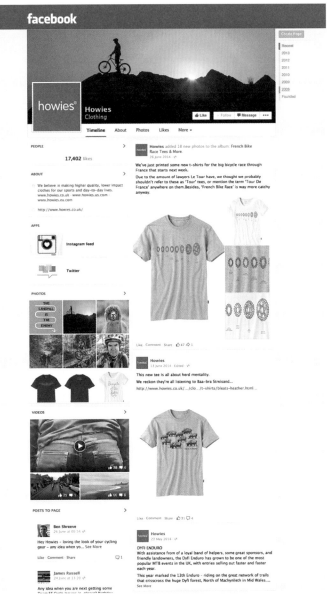

Of course, brands themselves must operate effectively within social media, too, raising many new concerns. Brands have learned to utilize social media to help drive awareness, and highly influential bloggers are invited to introduce brands and drive online conversation through social channels such as Facebook and Twitter. But if brands themselves have a blog, what are they blogging about? What are the products and services they offer? What are their special offers? Do they have any thought leadership?

Posts launching a product can generate thousands of 'likes' and comments on Facebook, indirectly reaching millions via the connections of those who have engaged with the brand. This kind of engagement has opened up new research opportunities, such as using instant polling tools to fuel online discussions, or connecting online discussion boards directly to an online survey.

This type of research reveals a level of transparency that surveys and focus groups would find difficult to capture – a result of the security users feel in the relative anonymity of the online world, which can encourage a degree of honesty that many people would not feel comfortable with in person.

Social media research does not require the physical cooperation of respondents, so there are reduced financial and practical barriers to finding participants, too. A further advantage is the opportunity to work with a much larger and more diverse number of people. This method also requires little planning, is time efficient and therefore inexpensive. However, it does have its disadvantages: the freedom of speech offered by anonymity of the Internet can also result in responses that are either unexpected or negative. Due to the openness of communication on the Internet, these responses can 'go viral' or be widely circulated, causing damage to the reputation of a brand.

If you can get your customer to 'like', 'comment', and/or 'share' content on Facebook, you are indirectly marketing to their entire sphere of influence; one single 'like' may potentially be seen by many friends on a person's contact list.

# Procter and Gamble

The twenty-first century has seen the use of 'bottom up' marketing grow dramatically through the use of social media, where the focus is on personal experiences of brands driven by consumers not marketers. Known as 'consumer-generated media', the platforms used include blogs and forums, which have helped supercharge word-of-mouth forms of communication. One company that has used this type of marking in a significant way is Procter and Gamble, which has been able to build a massive focus group of over half a million mothers to help the company problem-solve

and drive sales. A good example is the campaign created for Secret deodorant, which employed the Procter and Gamble-created 'Vocalpoint community' (through the website Vocalpoint.com). This online strategy brings together a community of women employing Facebook and Twitter to generate conversations, share opinions and offer samples. This particular campaign resulted in 100,000 women receiving samples and coupons for the new product, while 500,000 opted in to an online weekly newsletter.

The Secret Clinical Strength national Vocalpoint word-of-mouth campaign was deployed to the Vocalpoint community (mostly made up of switched-on mums) via Vocalpoint.com, Facebook and Twitter. The campaign ran across 40-plus touchpoints over nine weeks.

# VISUAL RESEARCH BOARDS

The design industry uses a variety of visual enquiry boards to explore ideas and capture emotions and styles. Traditionally these were created from a range of photographs, illustrations, colours and sometimes textures, often with accompanying descriptive words, to help capture a particular theme. The images were printed and applied to a 'board' – usually an A3 (or 11 x 17 in) sheet of card – hence the term. Some agencies still use this approach, although many now create them digitally, maintaining them as a presentation tool for clients and as part of their team research process.

There are three key types of board: mood boards, inspiration boards and consumer-profile boards, each having a unique purpose within the design process.

## Mood boards

A mood board (sometimes known as a tone of voice board) is a visual collage that projects a particular emotion or theme with a selection of pictures, colours and other visual elements. This visual analysis technique helps to define an aesthetic 'feel' or style, and is frequently used in the conceptual phase of the design process.

## Inspiration boards

Inspiration boards are also used as part of the idea-generation stage of the process. They are created to collate and organize imagery intended to inspire the design team's creative process. Sometimes they include elements that are close to the subject being explored, but they may also include elements that take the designers out of their comfort zone, provoking new ways of thinking and seeing.

### Creative platform 'Real food journey'

We know the trials and tribulations of discovering and enjoying real food. To make this journey good and simple we make real food made with love.

**Top:** Mood boards enable the creative teams to start 'visualizing' their design strategy. Sharing a themed approach in this way also allows them to stay close to the direction agreed in the brief.

**Above:** Inspiration boards can be used to collect graphic elements such as typefaces and colours to inspire the creation of a brand identity, but they can also be used to help explore straplines or brand stories.

## Designing a consumer-profile board

### Mini-brief 1

A simple but effective way to understand how to develop well-designed consumer boards is to produce one for an existing brand. The original design team has already defined the audience they wish to target, so all the hard work is already done. This exercise is in analysis, unpicking from the brand communication the type of consumer it is targeting and choosing specific images to reveal their lifestyle. Swapping consumer boards with a team member to see if they are able to identify the original brand can be a fun way to test their accuracy.

### Mini-brief 2

Exploring the contents of someone's handbag, school bag or briefcase can also be a highly effective way to learn intimate details about a target consumer. The items can be arranged and then photographed with further written analysis used to highlight thoughts and conclusions. Remember to ask permission first though!

## Consumer-profile boards

The consumer-profile board captures, through a variety of images, a visual outline of the type of person the brand is targeting. As designers are predominantly visual people, this type of research is usually better represented through tangible characteristics, rather than a set of data or a list of abstract descriptors. Consumer-profile boards are made up from a range of images about the consumer, and will include details such as:

- What they look like – age, gender, ethnic group
- Their job – profession, skill, income
- Their family and friends – children, wider family group, types of friends
- Their lifestyle – the type of car they drive, house they live in, holiday they go on
- The brands they buy – choice of supermarket, clothing, grooming accessories, homewares
- Interests – sports, music, literature, art, films

There are no set rules when designing consumer boards; however, there are a few considerations that will enhance their value:

- Only choose a few key images – too many can create visual confusion
- Consider scale, making important images larger than less important ones

Consumer Profile Case Study

The product is a new drink brand that provides healthy cold pressed vegetable and fruit juices. The juices are 100% raw in order to preserve all the nutrition and flavours from the ingredients.

**Maggie**
Age: 25
Occupation: Junior project manager

She loves yoga and the whole culture around it. She is a vegetarian and really cares about her health. She enjoys going out and travelling. She has heard about juice products but is unable to drink them as much as she would like due to thier cost.

**Josh**
Age: 33
Occupation: Financial advisor

He lives with his wife just outside London. His weeks are spent commuting and working, leaving him little time to do much else. He does kickboxing on weekends, when he can. Due to his busy work schedule he struggles to maintain a healthy diet. His wife follows a juice cleanse programme. He likes the juices she makes at home, but he is not really interested in starting a juice cleanse programme of his own.

**Ashley**
Age: 40
Occupation: Architect and mum

She leads a hectic lifestyle looking after two children and working full time. She likes jogging and outdoor activities and always tries to keep herself fit. She bought a juicer but only used it a couple of times, as it was too time-consuming and she realized how much easier it is to just buy from the shop.

- Design the layout carefully, including negative space to give each image breathing space
- Use a white background – colour can introduce an unwanted subliminal effect
- Make sure that any typefaces are consistent. with the look of the board and reflect the personality of the consumer
- Develop a range of boards rather than trying to explore all lifestyle choices on one board

Once this visual process has been completed, a design team will then often capture their thoughts of the consumer in the form of a written profile.

Visual research boards not only help to establish a clear direction for the design team, they can also improve client relations. Boards facilitate early client participation, and can demonstrate that the team have listened to the client's thoughts and considered their input, which fosters trust. The client, in turn, gains valuable insight into the thinking behind any creative ideas, dispelling the notion that creativity involves simply plucking ideas out of the air. Openness at this stage will also prevent any unwelcome surprises.

A further benefit to designers is that the process of preparing boards can help eradicate 'white paper phobia', or 'blank canvas syndrome' (see page 136), as much of the very early concept generation phase is dealt with even before pencil hits paper (or cursor moves on-screen).

# Consumer/Audience Research Process

**The Consumer/Audience**
- Who are you talking to?
- Why do you want to target them?

↓

**Consumer Profile Research**
- What are their needs, desires and aspirations?
- What and who influences them?
- What is their demographic group?
- What is their gender?
- What is their educational background?
- What is their occupation / economic status?
- Geographical location?
- What is their marital status?
- What is their family size?
- Can you define their life style?
- Can you define their attitude and behaviour?

↓

**Analysis of Data**

↓                    ↓

**Visual Analysis: Consumer Profile Boards**
- Lifestyle
- Brand world (the brands they already buy)

**Written Analysis: Written Consumer Profile**
- Who are they?
- Age, gender, social status
- Needs, desires, aspirations

This example of a consumer-profile board is for a new fresh cold-pressed juice brand. Key to the designer's understanding of this niche beverage market was appreciating the various potential consumer types.

# OTHER FORMS OF RESEARCH

## Case study interviews

Questionnaires are a great way of gaining data from large numbers of respondents, but they are not suited to in-depth research as they generate a relatively superficial view of a person's lifestyle. Case study interviews, or profiles, allow you to delve much deeper into the life of an individual or family, and can reveal insights in quite a different way. The researcher needs to develop a small number of trigger questions relevant to the individual that is taking part. These questions can be on any topic as long as it is relevant to the area of interest. They will anchor a discussion topic, and the individual's responses can be recorded for future analysis, either as a sound file or as a video. Photographs or film are also often used to record the individual's wider lifestyle, including their home, work environment, shopping habits and leisure pursuits, which can be analyzed to gain further insights.

It is, of course, vital that the individuals concerned give their permission for you to use images of their home and family as part of the research, and any investigation needs to be done in a professional manner. Let any prospective candidates know what the research will be used for, and ask them for formal (written) permission for it to be seen by others as part of a design project.

The analysis from a number of case studies can be an invaluable way to gain insights into lifestyles that are very different from your own experience, offering opportunities to understand how different people live and define their needs and aspirations.

## Consumer observations and interviews

Point-of-purchase observations and interviews can be a highly revealing way to explore who is buying what and why. Like case study interviews, this is a form of 'action research' that can be easily conducted by students. Undertaken in supermarkets and other retail environments, such observations enable the researcher to see first-hand what motivates purchasing decisions, how a consumer feels about a specific brand, product or packaging, and the success of promotional/merchandizing initiatives. These observations can either be achieved by simply observing consumers in the setting, or by arranging to accompany an individual during their normal weekly shop. Any point-of-purchase observations can then be followed up with interviews to gain insights into a consumer's thoughts, feelings and motivations whilst they are still fresh in their minds.

Things to record:

- How long people take to make their choices
- The brands chosen, and the size and number of items purchased
- Impulsive purchases versus planned purchases
- Purchase motivations
- Reasons for rejecting a brand
- Shopping experience and store layout (retailer performance)

Again, a professional approach is required in these situations. If you want to question people that you don't know, it is important to receive permission from a store manager before conducting any interviews. Offering personal identification may also be helpful to prove the validity of your request.

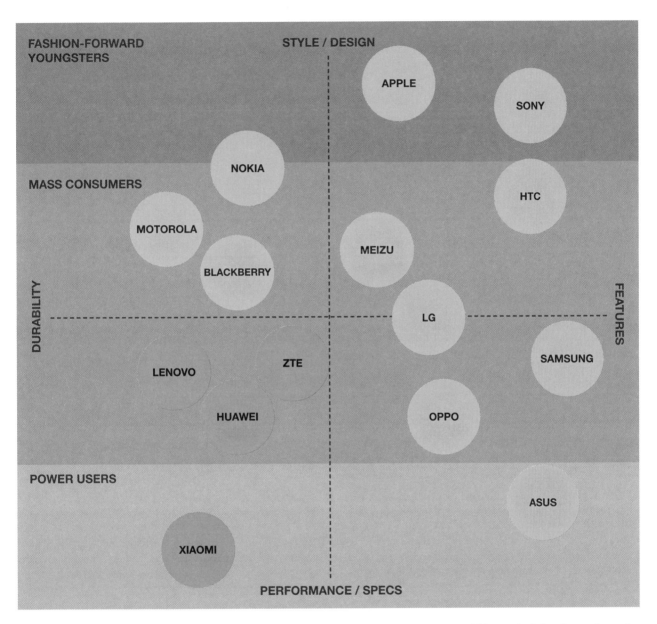

This example of a 'brand perception map' shows the key positioning approaches of the leading smartphone brands in the Chinese market.

## Questionnaires

People's time is very valuable, so if you wish to encourage them to take part in any questionnaire, ensure that the number of questions is limited. Anything over 25 becomes a chore, and the questionnaire should ideally only take between 5 and 7 minutes to complete.

- Make sure the questions are clearly written, short and unambiguous

- The design of the questionnaire is also important for clear communication of both questions and response boxes, speeding up the process

- Avoid open-ended questions that mean a respondent has to provide a long written reply

- Try to write questions that will prompt a simple 'yes', 'no', 'maybe', 'often' or 'never' response, or use an appropriate numerical scale

- Capture the interest of your respondents by explaining the project and what the findings will support, as this can incentivize them to take part

- Be persistent: many people may be interested in helping but may have forgotten. Politely remind them and try to give them incentives or encouragement

- Finally, proofread and polish the questions with a friend or colleague to ensure you have framed them to obtain the most accurate responses

## SWOT analysis

SWOT analysis is a technique that can be used to evaluate any product or service. Firstly the objective or aim has to be defined, and then the factors that are favourable or unfavourable to achieving that aim are identified. This type of analysis is useful because it enables researchers to not only identify a brand's unique selling point but also any existing threats to the brand.

- Strengths: characteristics of the brand that give it an advantage over others

- Weaknesses: characteristics that place the brand at a disadvantage relative to others

- Opportunities: elements that the brand could exploit to its advantage

- Threats: elements in the retail environment that could cause trouble for the brand

## Personal research

In addition to the formal research explored in this chapter, many designers also undertake personal inspirational research, often collected in journals and sketchbooks or by using digital tools such as Pinterest (see Chapter 7).

**INTERNAL**

**POSITIVE**

- Staff
- Customer base
- Market position
- Financial resources
- Sales channels
- Products or services
- Profitable
- Growing

STRENGTH

- Staff
- Profit margins too low
- Financial resources
- Competitive vulnerability
- Market research
- Lack of new products
  or services
- Sales channels

WEAKNESS

**S W**

**O T**

**NEGATIVE**

OPPORTUNITY

THREAT

- New complimentary market
- Strategic alliance
  – Funding
  – Sales
  – Products or services
  – Merger or acquisition
- Market poised for growth
- Competition weaknesses

- Economy
- Loss of key staff
- Lack of financial resources
- Cash flow
- New technology
- Increased competition
- New government regulations
- Falling sales
- Decreasing profits

**EXTERNAL**

An example of a SWOT analysis diagram, used to highlight strategic unique selling points in an existing brand or brand concept, as well as to identify any strengths and weaknesses, and any possible threats.

Where do you start? Asking questions is possibly the best place. Working as a team to develop a clear direction and identify any further research activities will enable a strategic approach to the eventual creative process.

# CHAPTER 6: ANALYSIS

The analysis stage of the research process involves design teams asking some specific questions. These are used both to generate starting points for design, and to help to identify where further research activities might need to be undertaken.

This section explores a group of analysis techniques commonly used to gain insights into brand competition and market segmentation. The conclusions drawn from this process will then go on to determine the style or tone of voice most appropriate to the product or service being branded.

# DEFINING THE USP

As has been discussed already in this book, the unique selling point/proposition (USP) is what differentiates a brand from its competitors, and what ultimately gives it its competitive advantage. The key to defining this advantage is by asking the question 'Why would the target audience choose this brand over all the others?'. Much of the research described in Chapter 5 can therefore be used to help determine the USP.

Once the USP has been identified, it is used to develop the positioning statement – a sentence or two that summarizes the essence of the brand in relation to its competitors, and is used to drive its communication strategy. This, in turn, is used to generate a strapline or slogan that, over time, will hopefully become synonymous with the brand.

This technique has proved to be a highly successful way of communicating a brand's uniqueness, as illustrated by Tesco's 'Every little helps', which transmits a helpful and money-saving message, or Stella Artois' controversially successful 'Reassuringly expensive' campaign, which highlights its exclusive brewing quality. Microsoft identifies its unique relationship with its users with the strap 'Your potential, our passion', representing itself as a vehicle for human creativity. While MasterCard – a brand that evokes an emotive reaction in each advert, print or broadcast – highlight that they are the only real choice with 'There are some things money can't buy. For everything else, there's MasterCard'.

# MARKET SECTOR ANALYSIS

Market sector analysis involves identifying the position a brand will aim to occupy in consumer perception. There are three broad market sectors, determined by their roles in satisfying either desires or needs. Satisfaction can be achieved either physically, psychologically, socially or emotionally. Our desires can sometimes seem endless, whether we consider ourselves wealthy or not. Needs are easier to define, but they do vary according to a person's age, physical environment, health etc. These are usually the basic stuff of life, such as food, water, shelter and warmth. The three market sectors are described as value or economy, regular or mid-market and premium or luxury.

Economy, value or necessity goods serve the satisfaction of basic needs. They are the things we literally cannot live without, and which are difficult to cut back on, even when times are difficult, such as food, electricity, water and gas. The success of economy products and brands depends mostly on the sales price. Their common 'home' is the discount shop or supermarket, DIY shops, furniture outlets, and mail-order and online businesses.

These cartons of orange juice successfully exemplify the market sectors that they have been designed to appeal to: the Tesco carton is an example of value for money, Tropicana is mid-market, and Coldpress is the premium brand.

The strong typography, bold colours and simple, unfussy designs used for value-for-money packaging is also often used for budget retail environments.

Regular or mid-market brands are generally designed for middle-class consumers with an average income, and are priced at a midpoint accordingly. These brands aim to offer good quality, but take care to show value for money as well.

Luxury goods or services are usually associated with affluence. As they are considered non-essential, they are usually targeted towards the upper middle and upper income brackets. The concept of luxury is packed with multiple layers of meaning, playing on consumers' desires and aspirations. These goods are commonly found in upmarket malls, airports and specialist stores.

Each of these three sectors has a visual language that is employed to trigger particular reactions or emotions. For instance, economy brands tend to use simple designs, basic imagery and a reduced colour palette, often using primary colours. The choice of type is commonly bold and simple, as is any packaging and marketing.

Mid-market brands in general are the most decorative of the three, using more colour, a wider variety of type choices, quality photography and illustration on pack and promotional materials.

**Centre:** Supermarkets targeting middle-class consumers often entice their target audience with displays of fresh produce or flowers at the entrance; these aim to 'prime' the consumer to think of freshness as soon as they enter.

**Below:** Mariano's Fresh Market provides their consumers with a unique shopping experience, including a wine bar, live music, and indoor and outdoor seating areas with a view of the Chicago skyline from the second-floor windows.

Luxury brands, however, revert back to simplicity, but handled in quite a different way from the economy brands. Often minimal both in colour and style, they appeal to our senses in other ways. These brands often explore 'stories' that enhance the brand's exotic 'lifestyle', perhaps by relating it to that of a distant land, or by emphasizing the feel of the handmade, reflecting the superior quality of the product. Heritage is another reference used by luxury brands, highlighting the customs and culture of a society passed down through the product to a new generation of owners. Typography is carefully crafted, sometimes using wide character spacing, decoration is usually minimal and stylized, and colours are carefully specified, alongside other printing techniques such as foil blocking, embossing and spot varnishing.

## Questions and techniques

Some of the key questions that guide market sector analysis are:

- What value would a new product bring to a prospective buyer?
- What price would they consider reasonable?
- What reasons might they have for not buying?
- What elements of the established 'design language' for this market influence the consumer's choice?

Commonly used market sector analysis techniques include:

- Being your own customer. By imagining yourself as your own customer, you can experience a product or brand from the consumer's point of view.
- Mystery shoppers

Having completed an analysis of the brand competition (see page 114) and market sector analysis, the design team will then consider which of the three market positions will be the most appropriate for the new brand. It is important to remember, however, that within each of the three broad sectors there is also a huge variation in price. Further consideration therefore must be given as to where the brand will sit within the sector in reference to its main competitors.

Three brands that explore the key visual languages employed to describe value for money, mid-market and luxury brands.

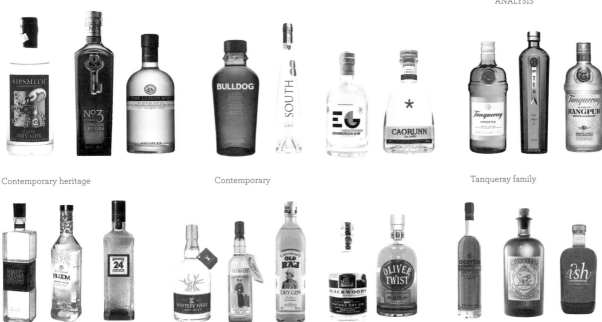

Contemporary heritage

Contemporary

Tanqueray family

Bigger brands do boutique

Traditional

Unexpected / interesting

# PRODUCT CATEGORY ANALYSIS

In designing the identity for Warner Edwards gin, one of the early steps taken by the design team at Bluemarlin was an analysis of existing gin brands.

There are strong similarities between market sectors and product categories, as both relate to differentiation within consumer markets. However, both have been included to give an understanding of terminology even though there are considerable crossovers between the two. Just as there are three main market sectors, there are also predominantly three main product categories: convenience goods, shopping goods and speciality goods.

In addition to the appropriate 'market language' that needs to be defined before embarking on the development of a new brand design, a design team must also gain an understanding of all relevant 'product language'.

During the twentieth and twenty-first centuries unique visual languages have come to represent certain commodities and services; these are defined by choice of colour, type, shape and image. For example, dark, rich colours, together with gold and italicized typefaces, tend to be seen on coffee packaging, while bright primary colours with an extensive use of white are typical for washing powders (see page 59). Before any creative work can begin, the design team must therefore research the language specific to the product category in which the new brand will be sited. This information can also be displayed as visual analysis boards, which will give the design team a visual overview of the current brandscape, as might be seen on a supermarket shelf, for example.

Once the analysis is complete the team will then use the information to define the new brand's product differentiation strategy. This will determine how the brand's unique offering will be reflected in terms of quality, price, function or availability – such as the time it is marketed (e.g. Christmas) or the venue it is sold in (as with unique local produce).

# COMPETITOR BRAND ANALYSIS

In today's competitive consumer marketplace, a new brand will be entering a sector already populated with powerful competitors. In order to gain a competitive advantage, a new brand or brand extension needs to position itself strategically, either by creating a new niche, or by competing within an existing one by making a stronger offer to the consumer.

Competitor brand analysis is a method for evaluating and comparing a brand's main competitors. Recognizing who your main competitors are, how they are positioning themselves, what products and services they offer and how consumers are talking about them is a reliable way to ensure that your brand is differentiated and makes a compelling offer. It is important to realize right at the start that a clear differentiation should be made between what a competitor sells (the product or service) and what they stand for (their promise or philosophy), as this perspective can also help to highlight any potential advantages for a new brand to capitalize on.

The challenge for the design team at Bluemarlin was to create a premium gin brand that is unique and desirable. To ensure differentiation from competitors, the research stage included a comprehensive visual analysis of other brands.

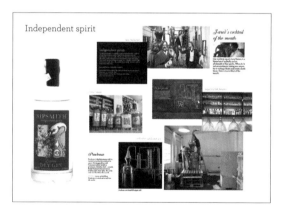

Independent spirit

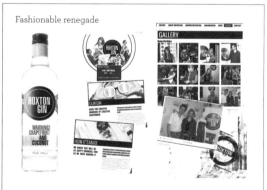

Fashionable renegade

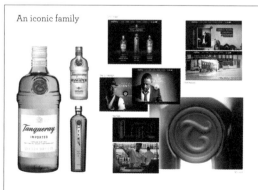

An iconic family

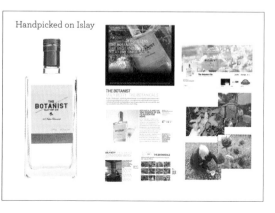

Handpicked on Islay

## Phase 1: Competitive audit

Developing a successful brand strategy depends on gaining as many insights into the competition as possible. This is not only vital at the early stages of the design process, but can also be used as a tool to measure the success of the final design.

Key questions used to guide this research process are:

- Who is the competition?
- Who is their target consumer/audience?
- What market do they serve – luxury, economy or niche?
- What is their price point? What is their market share? How popular are they?
- What does their brand stand for? What is their key message?
- What is their USP?
- What are their strengths?
- How do they position themselves?
- What are their strategies across all consumer touchpoints (see page 97)?
- What does their brand look like?
- What emotional message does it communicate?
- What is the brand's tone of voice?

From the conclusions of this first phase of competitor research a brand positioning strategy can be developed that will guide the design team and inform the creative process, enabling them to understand the market into which the new brand will enter. The second phase is to determine the visual aspects of the competition.

## Phase 2: Visual audit

Exploring how a competitor brand communicates to its consumers involves looking into all the design aspects of that brand's identity, including online, advertising, packaging and promotion. This process aims to unpick the hidden meaning behind all the elements of the design, as was demonstrated with the semiotic deconstruction of the Milka brand in Chapter 2 (see page 51).

The key factors to explore are:

- The tone of voice. Who is it addressing?
- The look and feel. What visual message is it communicating? What emotion is it expressing?
- The typeface. What characteristics does it have and why?
- The colour palette. How does this add to the feel and message?
- The brand icon/logo. What is it and why does it use it?
- Any additional elements used in the advertising, copywriting and promotion of the brand. How these are used to amplify the brand message?

Analyzing the visual elements of the competitor brand will identify what its designers intended to communicate and how they were able to achieve it. This will create a clear understanding of how the current competition uses visual triggers to communicate their message, and will ensure that the design team approaches the creation of the new brand in an original manner, developing a unique visual solution.

The first step in undertaking this type of analysis is to do background research on how the brand was initially created. This information can often be found on the website of the design agency involved.

The second phase is to explore in detail the visual elements used by the design team to create the unique aesthetic of the competitor brand and then any textual information used to promote the brand.

In the case of premium gin Warner Edwards the design team creating the identity of the brand was the Bluemarlin's London studios, and it was the unique brand story of friendship that inspired and guided the design. The two founders of the brand Tom Warner, from England, and Siôn Edwards, a Welshman, met at agricultural college. They became friends and, even though their farms were geographically separated by the Welsh border, they had an idea that would allow them to work together. The concept was to create a premium gin sourcing the ingredients from each of their farms.

The designers wished to capture the brand's story with iconography representing the relationships behind the brand as well as its premium appeal. The brand graphics depict a weather vane pointing west to Wales and east to England, with the letters 'E' and 'W' standing for not only the orientations and nations involved but also the founders' initials. The same message is communicated on top of the vane where a dragon, symbolic of Wales, shares a glass with a lion, representative of England. The typography used has a traditional feel, developing the sense of premium quality, and the use of capitals gives the design strength. The brewers' names are defined in different typefaces reflecting the founders' separate identities – the essence of which is captured in the strapline 'united in spirit.'

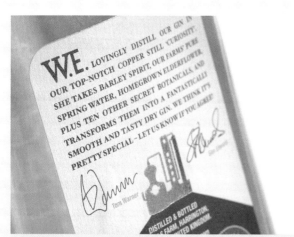

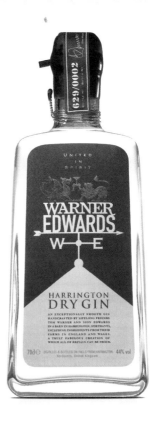

Although many of the elements of the design are traditional, the use of a pared-back colour palette lends the overall design a modern feel, again highlighting the premium nature of the brand. The strong geometric triangular representation of the roof gable adds dynamism to the design and underlines the importance of the brand story captured within the negative space. The copper foiling defining the lion and dragon not only lifts the simple colour palette but also reflects the qualities of metal used in the still, a key unique selling point for the product.

The design team have also utilized three-dimensional elements to develop the premium quality 'triggers' for the brand, including the application of copper wire around the neck of the bottle as a link to 'Curiosity', Warner Edwards' bespoke copper pot still. This unique piece of brewing equipment is used to ferment the barley and features in an illustration highlighting its importance. Finally the bottle is sealed with a unique number tag that also carries the signatures of the makers, thus offering a personal guarantee and a sense of origin and originality.

It is this type of in-depth analysis into the visual language used by other brands that helps designers define existing aesthetics and gain an understanding of how to develop novel and unique approaches for new brand communication.

It was Warner Edwards' unique brand story and traditional distilling methods that gave the team and Bluemarlin a brand story that enabled them to create this unique and memorable identity.

From the use of British symbolism – the Welsh dragon and English lion – to the personal signatures guaranteeing the brand promise on the back label, this brand deeply imbeds the key aims of successful brand creation.

## Conducting a simple competitor brand analysis

1. Start by choosing a brand to research. You can search the Internet for products and brands, or look through product catalogues or trade magazines.

2. Identify five main competitors for your research. It is useful to ask somebody else to review your list of competitor brands to ensure that the most important competitor brands are represented.

3. Compare all of the competing brands to discover the strengths and weaknesses of each one. Use the key questions listed above to guide this analysis.

4. Add to this list one company that you consider to be the best example of a brand. This one does not necessarily need to be a direct competitor, but if it is more relevant to your chosen brand this will help you to build useful data. This will be your benchmark example of who you think is doing a good job of positioning themselves.

5. Write up a short summary detailing all of the competing brands and their overall market position.

6. Finally, add one more business – not necessarily a competitor, but one in your brand's industry – that you think is not doing a great job at positioning themselves. This will help you see what not to do with your brand design.

7. If you want to carry this exercise further you can simply create a longer list by searching for other brands to add to it. Doing this will also have the benefit of showing you who else is out there, and what they are saying.

## Competitor Research Process

### Competitor Analysis

- Who is the competition?
- What are their strengths?
- What are their weaknesses?
- What is their key message?
- Who are they targeting?
- What price point are they at?
- What is their market share/how big are they?
- How do they position themselves?

### Competitor Brand Analysis (Visual and Semiotic)

- What look and feel does the brand have?
- What visual message is it communicating?
- What emotion is it expressing?
- What characteristics does the typeface have? Why?
- What is the brand's colour palette? How does this add to the feel and message?
- Does it include a brand icon?
- Does the brand have a strapline? What typeface does it use? Why?
- How does this add meaning to the brand?
- How do they position themselves?

### Environment / Retail / Online Communication

- Explore how the competition communicates to its audiences in different contexts
- How do they grab attention?
- What is the level of 'visual noise'?

### Image Board Development

- Create A3 (or 11 x 17 in) boards that visually explore the analyses from the previous steps

### Evaluation & Conclusions

- Where are the opportunities?
- What are the perceived threats?

# ANALYZING THE BRAND ENVIRONMENT

The environment into which a brand is introduced can have a marked effect on its ability to communicate to its audience. Brands have to compete for attention with other brands in complex retail environments and online, so a design team developing a brand identity will undertake analysis of a brand within a retail store environment, a company website and third-party retailers to uncover how it communicates to its audiences in a variety of contexts. Key questions to ask include:

• How does the brand competition communicate to its audiences in different communication contexts?

• How do they grab attention? What are the key design elements they use?

• What is the level of 'visual noise'? How many brands are in the retail environment and how loudly are they shouting?

The answers to these questions will also be backed up by evidence gathered by visiting retail stores, including photographs of store layouts. Analysis of this material will provide an understanding of the consumer experience in store. Design elements that can have a strong impact on the consumer include signage, interior design, visual merchandising and point-of-sale areas. Signage gives information and a greater understanding of the brand identity and values. Interior design can affect the consumer's physical and sensory relationship with the brand. Visual merchandising increases consumer awareness and boosts the product's appeal.

# Fazer Café

## Challenge

The original Fazer bakery business was established in 1891 by Karl and Berta Fazer and has become one of Finland's largest food companies. The challenge for the design agency Kokoro & Moi was to develop a new identity for its café chain, including the brand and merchandising as well as a unique branded environment with the particular qualities of elegance and leisure specified by the client.

## Inspiration

The identity developed by the design team was based on original signage that hung above Fazer Café's Kluuvikatu store. Kokoro & Moi created unique bespoke typefaces named Fazer Grotesk and Fazer Chisel. Creating the visual identity from a custom typeface enabled the brand to offer a modern café experience whilst making reference to the company's significant heritage.

## Solution

The typefaces created by Kokoro & Moi are utilized everywhere from the logo to the menu boards and price tags. The application of single characters used on the packaging materials is particularly striking and is continued in the design of clothing and the decor of the walls. Other custom-made graphic elements from the identity, such as Kokoro & Moi's pattern designs, are used for wallpaper, napkins, take-away packaging and staff accessories.

The spatial design created for the café was developed in collaboration with the interior architecture office Koko3. The brand's simple aesthetic, which captures the company's past heritage, has influenced key interior design features such as the choice of light fittings, furniture and wall treatments. These carefully considered elements all add to and develop the unique tone of voice created for the café.

The first new Fazer Cafés were opened in summer 2013 in Munkkivuori, Helsinki and in the Stockmann department store in Tampere. These have been followed by two more in Helsinki, and other locations are in the pipeline.

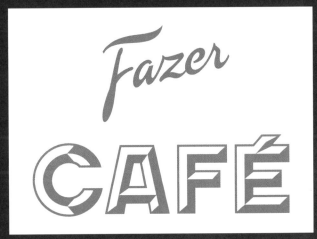

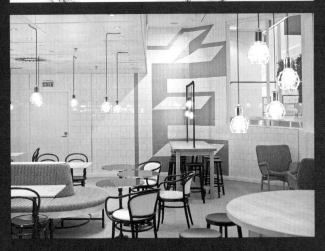

# FUTURE FORECASTING

Much of the analysis described in this chapter has involved exploring and highlighting the current context in relation to markets, brands and consumers. However, if a brand is to have longevity, the design team also needs to have an understanding of any future influences that may affect it. This information is based on a form of research and analysis known as 'future forecasting' or 'trend forecasting'. Sometimes undertaken by specialist agencies, it explores short- and long-term drivers that influence society and how they may impact on businesses and consumers. Areas of focus include politics, economics, technology, environment and law, in addition to less tangible forces such as culture, lifestyle, consumption, well being, ethics and values.

The aim of future forecasting is to observe trends as they emerge and make predictions for the future; these 'future narratives' are then used to inform the activities of creative teams, as well as those working in many other fields too, such as politics, economics and academia. For branding designers this type of research is invaluable – it enables them to integrate new ways of thinking that may influence the final design of the brand and its methods of communication.

# ANALYSIS OF DATA AND INTERPRETING OPPORTUNITIES

At the end of any research phase, the data collected needs to be analyzed and evaluated. Conclusions are derived that form insights into the target consumer, the market and possible ways to communicate a new brand effectively. In the case of market positioning and product category analysis, the key decisions to be made are where the new brand will be positioned and how it will communicate effectively in the current brandscape. These decisions will be used to underpin the brief and brand strategy.

As designers are primarily visual, creating research analysis that utilizes images is one of the most successful ways to capture your findings and draw conclusions.

This approach makes the data more accessible to both the design team and the client. For instance, numerical statistical data can often be difficult to understand in its raw form; a diagram or infographic can make its implications clearer.

## Visual analysis boards

As mentioned in Chapter 5, visual analysis boards are commonly used throughout the research and design development phases of a project to convey information to others: either the clients or other designers within the design team. However, if poorly conceived and designed these boards can be confusing or misleading. It is vital that they are concise and focused to show encapsulated thinking and reveal real understanding.

Keep the design as simple as possible to allow the images to communicate effectively, and ensure that all the images are chosen with care so that they accurately reflect the point being communicated. A badly selected image can cause confusion and, once designing is underway, it can cause the designers to be 'off target'.

When designing an analysis board, use appropriate titles to ensure that the visual information displayed is understood in its particular research category. This will aid both the design team and client.

### Designing visual analysis boards

1. Using the design guidance given on this page, choose a product you wish to brand, consider which market sector is most appropriate (luxury, mid-market or economy) and create your own visual analysis board.

2. Using the same product, develop a 'product language' board using the example to guide the choice of images and the layout.

There are now online sites that help you create digital mood boards, including Polyvore (www.polyvore.com), which is similar to Pinterest but with the facility to create collages of images.

## Competitor analysis

# Evaluating the data and reaching conclusions

The quantity of research that needs to be undertaken before the creative phase of the design process can begin can seem rather daunting, and many larger agencies will employ a professional team to undertake this work for them, leaving them free to focus on creative development. However, each phase of the research process plays an extremely important role in the successful design of a new brand.

Before the brief and design direction is finally written, an analysis of all the research must be undertaken, providing the design team with the following information:

### Consumer/audience

- A clear understanding of the target audience, their lifestyle, needs and aspirations
- The appropriate way to communicate to them, verbally and visually

### Competitors

- A clear understanding of the competition, and their strengths and weaknesses
- How they communicate and interact with their consumer or audience
- The key opportunities and gaps in the market
- The threats posed by existing or emerging brands

### Market sector

- A clear understanding of the key visual commonalities across the market sector

### Product category

- A clear understanding of the visual language related to the product/service category

### Future trends

- What new insights could be utilized by the new brand related to emerging trends, such as changes in consumer habits or perceptions, new technologies or methods of communication

## Product/Market Research Process

| PRODUCT CATEGORY Analysis | Visual Analysis | Evaluation & Conclusions |
|---|---|---|
| • What is the visual language that is currently used to communicate the product or service? | • What are the key colours used?<br>• What characteristics do the typefaces have?<br>• What other graphical elements are used to communicate the product or service? | • The key visual commonalities that occur across the product or service category<br>• Other points of interest |
| MARKET SECTOR Analysis | Visual Analysis | Evaluation & Conclusions |
| • What market is the product or service targeted towards (luxury, upmarket, mid-market, economy)? | • What are the key colours used?<br>• What characteristics do the typefaces have?<br>• What other graphical elements are used to communicate the product or service? | • The key visual commonalities that occur across the market sector<br>• Other points of interest |

# The design brief

The final step of the analysis stage is the creation of a 'design direction', or design brief. It is a written explanation of the aims, objectives and milestones of a design project. A clear and comprehensive design brief helps to cement trust and facilitate understanding between the client and designer, and serves as an essential point of reference for both parties throughout the duration of the project. Above all, the design brief ensures that important design issues have been considered and resolved before the designer starts work.

It is vital that the team reads and re-reads the brief regularly throughout the creative process. Using visual analysis boards to support the brief also ensures that the aims of the brief are met.

Developing a good written brief is an art in itself. Using a variety of headings or trigger questions will ensure that all the information collected during the research phase is integrated into the document. Key points to include are:

**Background.** Any information related to the project, including information about the product or service to be branded, what it does, why it does it and how it does it.

**Aims and objectives.** The problem the client wishes the team to solve and any challenges that have been identified. All the key creative elements that will need to be addressed, such as brand creation, extensions, methods of communication and so on.

**Target audience.** All the information gathered on the intended consumer, for instance age range, gender, social status, lifestyle, needs and aspirations.

**Tone of voice.** The style that has been identified as being the most appropriate for communicating the brand message to the audience.

**USP.** The unique selling point and how it will be used to develop a clear communication strategy. What will be the benefits of this brand for the consumer? Why will they buy it rather than competitor brands?

**Creative outcomes.** All the creative elements, such as brand identity, strapline (slogan), website, advertising, promotion, packaging etc.

**Budget and delivery schedule.** Sticking to the deadline is vital. The client needs to know that the brand can be released onto the market on schedule. All costings should be defined and detailed so that the client can see what they are paying for. Any extra work demanded by the client can be added later, ensuring clarity between the two parties.

**Consultation process.** A schedule of meetings with the client, to allow them the opportunity of giving feedback during the creative process.

Remember that the design brief is a professional document that also acts as, or supplements, a contract between the client and the design agency. It should be written in a clear and precise manner, using appropriate language.

# BRAND CREATION STRATEGIES

Once the findings of the research have been captured and the brief has been written and agreed by the client, decisions need to be made about the type of strategy needed to develop the new brand identity. Depending on the outcome of the research, designers need to consider how to approach the development of concepts.

## Evolution or revolution

One way to undertake this development is an evolutionary approach where the design relates closely to the existing market leaders. The second approach is to revolutionize the market sector by creating an innovative new language within the product category.

This 'evolutionary or revolutionary' distinction is also used with existing brands that are undergoing a redesign, as it enables designers to demonstrate how far their ideas have moved away from the existing identity. A useful tool when demonstrating this approach is to use a linear scale from 0 to 100. This is presented like a timeline, determining, for each potential design, the amount of change the brand has undertaken, with the existing design placed at 0.

A similar technique can be used in the creation of a new brand, demonstrating the level of new thinking reflected in each design relative to the market sector or product language.

## Mild to wild

A slightly different approach is to use a strategy that creates a variety of ideas that are either understated or outrageous – or 'mild to wild'. This can also be visualized in a similar way to the previous strategy, with the least outrageous ideas at one end and the most outrageous at the other, with additional ideas in relation to them along the line. This approach also helps to clarify for clients how the designers have tackled some of the issues defined in the brief, ensuring that they understand the process undertaken.

This example of a 'mild to wild' concept strategy demonstrates three different design solutions for a brand identity. It offers the client a range of approaches, stretching the original brief from safe to imaginative.

# RESEARCH AND ANALYSIS IN AN EDUCATIONAL SETTING

This chapter has focused on how the design industry analyzes research to inform and guide the creative process, revealing both the complexity of the process as well as its extent. In an educational setting, this may seem to be impossible to replicate. However, with the aid of new research opportunities offered by the Internet, much of this work can be undertaken by staff and students utilizing Google images and research tools such as SurveyMonkey. Many of the research techniques used, such as focus groups and questionnaires, are also viable in a student environment, as are all the visual analysis aids such as mood boards and consumer profiles. Undertaking this sort of personal research and analysis provides you with a 'real life' context into which to set your own creative practice; it also adds to your awareness of professional practice, which is valuable when seeking work experience or employment.

What many students find difficult is not the research so much as the analysis and evaluation of the findings, and how to implement them within their own creative process. However, if you integrate the habit of making decisions and developing insights at each stage of your research process you will find that you gradually gain an understanding of the role this plays within the creative process.

Writing the brief will highlight any issues, too, as each heading must be addressed in turn. This will reveals any gaps in knowledge or understanding before the creative process starts. In addition to the practical elements of the brief, you may also want to include some personal objectives – things you may want to improve upon during the project, such as project management skills, time management, or IT skills (such as the use of Illustrator or InDesign).

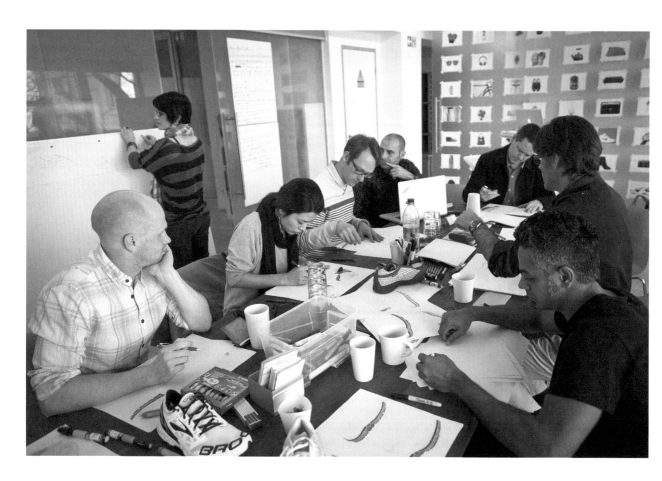

Inspiring and facilitating innovation is the key to creating great design solutions. This design team includes both client (Brooks, a sports shoe manufacturer) and IDEO designers, collaborating side-by-side from day one.

# CHAPTER 7: CONCEPT DEVELOPMENT

Having undertaken the necessary research and analysis to define the brief or design direction, the next phase in the design process is to develop a range of ideas or brand identity concepts. To create outstanding work, designers need more than good software techniques and typographical skills: fundamentally strong design is about ideas, and lots of them.

Great design is defined as imaginative, daring, individualistic and innovative, but where do these ideas come from and how can you nurture them? This chapter explains why we need to look for inspiration and how it can be used to support the creative process. It will identify the different approaches to developing initial ideas, and explore the techniques available to help pull these early ideas together into strong brand identity concepts.

# INSPIRATION

Most designers know that finding good sources of inspiration to feed the creative process is one of the most important factors involved in developing great design concepts, but finding a source of inspiration is not as easy as it sounds, as what inspires each individual is unique to them. Inspiration may be visual, three-dimensional, textural, musical or even involve some form of physical activity. Most creative people usually know the types of things that stimulate their ideas, but it is always useful to explore other alternatives to find new triggers and ways of thinking. Simply noting down experiences and collecting sources of inspiration in a journal can be a fruitful way to develop strategies to enhance creativity, too. In the same way that athletes have to train their bodies to achieve fitness for professional competition, designers have to train their own imaginative strengths before they can successfully become professional creatives.

## How to find inspiration

In this section you will find suggestions that may help you to locate sources of inspiration. Some of these techniques are tried-and-tested ways of sparking off your creative process; others may be new to you. Remember that time spent looking at images in print or on screen is only one approach to finding inspiration, and it will rarely be as good as first-hand experience, where colour, texture, movement, size and proportion can all make a strong impression on you. A photo of a music festival will never replicate the experience of actually being at one.

## Looking

• Other creative people are an invaluable resource and source of inspiration. Start to follow the blogs of people you admire. Print out work that has a resonance for you, as hard copy can give a reality to images that on-screen viewing cannot.

• Have a magpie attitude to inspiration. Seek it from all sorts of sources: photography, textiles, ceramics, architecture, calligraphy and so on. Observe people in the street, watch films, read, consider the gestures people use or the colours they wear. Take in little everyday things and observe them with a critical eye, and use all these elements to build up a sketchbook or visual resource that you can draw on when you need to.

**Below:** Creating a resource of inspirational blogs, either as a source of general inspiration or as specific areas of research for individual projects, ensures your work is both current and informed.

**Opposite:** Creating and maintaining a personal design journal or sketchbook is also essential for documenting research and capturing ideas, reflections and concepts.

## Asking

- Be collaborative. Gather inquisitive and reflective people from all disciplines across education, work, and friends – a cross-pollination of ideas makes for interesting and exciting outcomes.

- Questions often open the doors of the imagination. Before searching for any specific inspiration, ensure that the aim is clearly defined, through either a single key question or set of questions. This will help to define the journey.

## Learning

- As branding is ultimately about people, immerse yourself in the world of your target audience to develop empathy with them. Observe them, learn to understand what drives and motivates them, what their fears and desires are. This will help you to appreciate their needs and identify the appropriate language to use to communicate with them effectively.

- Harness teamwork to help inspire you, as the rapid bouncing back and forth of an idea can generate compelling concepts at amazing speed. Brainstorming, or mind mapping, takes advantage of the power of the group to explore new possibilities and achieve more collectively than any one individual can. An added benefit of this way of working is that it relieves the pressure on the individual to come up with ideas.

- Listening to music is one of the most common ways used to inspire the imagination, as it is incredibly evocative. Try to find a piece that reflects the subject you are working on – one that relates to the 'emotion' of the brand.

## Evaluating

- Analyze what you see and what you have collected. Take time to reflect on why you have chosen certain pieces of inspiration. Ask yourself what they mean. Understanding the meaning behind any images and making notes helps to deconstruct and then appreciate an object of inspiration. This approach allows the development of a new set of personal thoughts to occur, which can lead to creative insights. Without reflection the sketchbook is merely a collection of visual material that will provide little inspiration.

**Left:** Teamwork is not only a creative way of working, it is also much more fun than working alone. Collaborative concept generation also frequently results in a greater range and number of ideas than individuals by themselves.

**Above:** There are a number of creative processes involved in sourcing your own visual research. The first occurs in the initial collection, the second via collation, and finally, in analysis and reflection in order to generate conclusions.

- Value mistakes – they too can be inspiring. Fear can shut down creativity, as can the pressure to impress, so take risks and do what scares you. Embrace new challenges. When we are stretched we tend to be more creative.

And if you get stuck…

- Daydream. Give yourself time and permission to do nothing. Bus and train journeys are great opportunities to just sit. Turn your phone off! Hard work is not always productive; the brain needs periods of inactivity to rest and process previous thoughts and ideas.

- Always carry a notebook and something to draw or write with; you never know when an idea may strike! A pencil in the hand not only captures an idea, it also helps the mind focus and aids thinking. What is seen in the mind is ephemeral; the validity and success of an idea can only be explored in reality through drawing.

- Mobile phone cameras and digital cameras are also a great way to record inspirational images immediately.

- Doing can also be highly inspirational. You do not have to wait for a good idea to come. Start by realizing an average idea – no one has to see it!

- Try to remove any ego from the process, as it can get in the way of gaining new insights and identifying new ways of working.

## TIPS & TRICKS

Routine is really important. However late you went to bed the night before, get up at the same time each day and get on with it.

If an idea over-excites you, take a break and come back to it later. It is good to develop a critical eye.

Creativity is like a muscle: if you do not use it, it becomes flabby and unfit. Use a creative journal to capture and keep ideas, and as a way of collecting and analyzing inspiration.

Be constantly curious about everything. Always ask why.

Everyone has that small voice that tells us we are rubbish – learn when to silence it.

Genius is 1 per cent inspiration, 99 per cent perspiration. Be motivated, work hard and relish all opportunities.

Below, left: Many of us have been reprimanded for daydreaming as children. However, this activity actually allows your imagination to expand and explore. Do it as often as you can!

Below, right: The quality of images captured on a phone camera is now far superior to even a year ago. Mobile phone technology is developing every day, making it a highly effective research tool.

# THE BIG IDEA

Sometimes also known as the 'eureka' moment or the 'creative hook', the big idea is the point where research and inspiration meet the problem to create a unique personal insight or idea. Sometimes experienced in a highly physical way by creative individuals, it is usually accompanied by an image seen in the mind's eye, often in such detail that it seems that if only a screenshot of the idea could be taken, the design problem will be solved in a moment. At this stage it is vital that the idea is captured as quickly as possible, as such images are highly ephemeral and can be lost or transformed in a moment if you are suddenly distracted.

It is a common misconception that these moments come as if by divine intervention, and only for geniuses. These experiences can, in fact, come simply as a result of remaining open and thoughtful about what you observe every day, and by collecting all sorts of inspirational material.

But what is a big idea? In the case of brand identity there are some key aspects that can help define one:

**A big idea feels like, or is built on, an authentic impulse.**

It usually strikes an emotional chord although it has a rational appeal, is powerful and has the ability to communicate to its target audience in a meaningful way.

It must be distinctive and may represent a totally new way of thinking, acting or feeling.

How will you know if your big idea is also the right idea?

Does it turn heads and demand attention? Are people compelled to discuss it and share their thoughts and feelings about it?

Does it push the brand in positive new ways that do not strain its authenticity or believability?

Is the idea universal? Will it allow the brand to transcend cultural and geographical boundaries to speak to people at a fundamentally human level that cuts across class and ethnicity?

These are key pointers that can help to differentiate a great branding idea from a mediocre one. Remember: great ideas solve problems.

## Personal / Design Team Inspiration

### Trends Analysis
- Examine insights gained from exploring new fashions/directions
- Visualize key themes that may be relevant to the project

### Personal Visual Enquiry
- Personal research to gain inspiration
- Keep the search initially very broad. Use books, magazines, internet, shopping, that box under the bed!
- Visualize useful elements, in physical or digital format. Use Pinterest, tear sheets, boards, sketchbooks, PDFs

### Design Team Visual Enquiry
- Group sessions bring together visual elements from all the previous research to gain insights into current styles
- Create visual inspiration: make walls of all types of inspiration relevant to the project

# VISUALIZING AND ANALYZING INSPIRATION

Previous chapters have introduced the technique of using boards to convey information to clients or others within the design team. To recap, there are three key types of board that are used within the design process: consumer profile boards, mood boards and inspiration boards. Here we will focus on developing mood boards and inspiration boards, and how these visual analysis techniques are used to generate ideas and concepts.

## Mood boards

In the same way that people with strong personalities have a distinctive and recognizable voice, a brand identity needs to be developed to reflect a strong brand personality. A brand personality allows the consumer to engage with the brand, communicating a clear set of values and attributes that are inherent in the brand's promise or offer, differentiating it from the competition. By developing a unique brand personality and tone of voice, the design team ensures that all subsequent elements of brand communication are consistent, maintaining the brand's credibility with its market.

A technique often applied by design teams is to consider the brand as if it were a real person, the question posed being, 'What would be their personality, individual characteristics and how would they communicate?' As with a person, what the brand says should be dictated by its principles and aspirations; how it expresses it is informed by personality.

Exploring how existing brands have developed their unique personalities is always a useful way to understand how this process works. For instance, compare the two well-known brands, Orange (the telecommunication company) and HSBC (the Hong Kong and Shanghai-based bank).

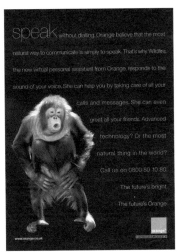

By integrating a brand's verbal identity with business objectives and by creating 'language palettes' reflected in visual communication such as adverts, brands can achieve a tone of voice that successfully engages with their audience. The way a brand communicates therefore has to be as unique as the brand itself, as exemplified by these two examples: HSBC conveys a sense of being friendly but authoritive; Orange appears fun but reliable.

When Orange launched in 1993 its use of everyday language flouted the sector conventions applied by other telecommunication providers at the time. Orange had made a decision to position itself as accessible, friendly, honest, straightforward, humorous, people-based and optimistic.

By contrast, HSBC, as a global finance provider, wanted to create a voice that was solid, steady and reliable, offering customers a safe harbour in today's volatile financial environment. Although also supportive, HSBC has developed perhaps a more formal persona than Orange, although it is careful to remind us all of its friendly status as 'the world's local bank'.

Applying this approach to developing the unique personal characteristics of a new brand allows designers to create a set of descriptive terms, or brand values, that will focus and direct the search for images that highlight and communicate these terms.

## Inspiration boards

Inspiration boards are another visual analysis technique used to generate ideas and concepts. Using the mood board as the source to define the inspiration, this board then curates graphical elements portraying the brand's persona. Starting with colours, shades and tones chosen to define the personality of the brand, this can then be developed into a brand's colour palette.

Fonts are chosen that match the look and feel the brand needs to communicate. Typography is as sensitive as a facial expression in depicting complex emotions. The brand's mood can be defined through existing typefaces, which may be developed further into a logotype – a unique and hopefully instantly recognizable visual rendering of the brand name.

Further inspiration can be found by sourcing other graphic elements, such as illustration and photographic styles, movie posters, CD album designs, book jackets, digital apps, website icons, buttons and layouts – anything that highlights the personality traits of the brand. If appropriate, even

## TIPS & TRICKS

To understand how to design a successful mood board, develop one for an existing brand. Examine the brand's values and its personality, and create a mood board that incorporates both images and words that reflect the persona of the brand. Use stock image libraries such as www.123rf.com or www.dreamstime.com to source appropriate images, or take your own.

furniture, architecture, fashion, textiles and accessories can help to define the message that the brand is expressing.

A key factor in the success of these boards, however, is that the design team know why they have chosen the examples and are able to articulate the reasons. Brands are based on clear communication and meaning, so each stage of a development has to reflect the same focused thinking. A badly conceived board can be worse than useless, giving false clues and confusing the creative process.

**Below, left:** These inspiration boards created for Oykos Greek yoghurt by Dragon Rouge demonstrate how the design team used images, colour, words and type to inspire three different tones of voice.

**Below, right:** The inspiration boards are then used to influence the concept development phase, as demonstrated by these digital renderings of the new branded Oykos packaging.

# INITIAL CONCEPT IDEAS

The process of exploring and developing initial ideas can be full of frustrations and pitfalls. However, there are a range of different tricks and techniques that can guide the development of successful concept ideas.

## The benefits of sketching

Even in today's computer-aided world many designers argue that the sketch is still fundamental to the first stage of the design process, insisting that the relationship between brain, hand and paper is still the best way to visualize ideas seen in the imagination. But why apply an age-old process when there is so much available to the designer using a computer? Consider these points in favour of sketching:

### The first idea is rarely the strongest

The first thought that comes into your head is sometimes a mere knee-jerk reaction, as it is based on an unconscious impulse. Do not disregard it, however. This is just the beginning. Sketch it – it will only take a few seconds and it will help get it out of your mind and onto paper. Now develop more sketches, as the quality of the first idea has no context until there are others to test it against. Often as the ideas progress there will be a whole host of more interesting and creative approaches that would not have developed if the first idea had been chosen. Do not be too quick to pick one however, as even spending hours in Illustrator crafting the text and refining it will not make it a better one. Give ideas time to grow and develop.

### Sketching is physical

Our relationship with pencil and paper has developed over centuries, if not millennia, and these still provide the most accomplished tools for drawing. Learn to love what you can do with them – things that are not possible on screen; the mouse is only a lump of plastic after all! Embrace pen, pencil and paper, and watch how fast the ideas come. The experience of this, when concepts seem to pour out of you, is sometimes known as 'being in the flow'. The freedom to just scrawl out unformed rough ideas is a great way to continue the inspirational phase, allowing you to reach unimagined creative places.

However rough your first ideas may seem, they are a vital first stage in the creative process. What you see in your head is ephemeral and will only exist if it is made explicit. Drawing is the natural extension of your imagination.

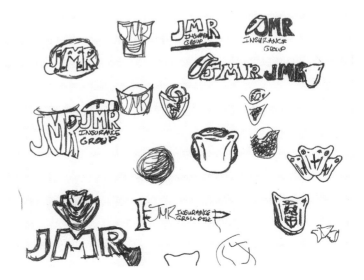

### Sketching saves time

Involve the design team or creative colleagues in
the early concept creation phase – getting feedback
at this stage can save hours of rethinking later on.
If the ideas have missed the brief or have the wrong
tone of voice, it will only take a few seconds to
sketch a revision, rather than many wasted hours
in front of the screen.

### Only artists sketch

But so do children! Do not be self-conscious about
the marks you make. Be happy to just rough out an
idea, because that it all it is – 'rough'! Renaming this
process can also be helpful as it removes the 'fine
artness' from the process; other terms include
'visual note taking' or 'graphic recording'. These
techniques also use text, typography, personal
comments, cut-and-paste images, flow charts and
diagrams, all designed to capture ideas in whatever
way works best for each individual. Choosing the
right pen, pencil, paper etc. can also enable the
sketchbook to become a friend. Try to sketch all the
time, not just for work projects. Keep a personal
journal that includes this type of graphic recording
– it is fun once you get over the old hang-ups!

## White paper phobia

For students and professional designers alike, an
expanse of virgin white paper can often prevent the
flow of ideas and cause 'designer's block'. There are
a number of reasons why this occurs, but there are
also some very practical ways for solving it.

The first is to return to the brief and the visual
inspirational materials created to support the
project to ensure that the aim of the project is clear
in your mind. If this does not work, spend time
searching for a new 'creative hook' by exploring
inspirational material. If this does not prove
successful, the addition of inspirational images
directly onto the concept sheet to act as a visual
catalyst can be a highly effective way of populating
the white expanse and giving the imagination
something to build upon.

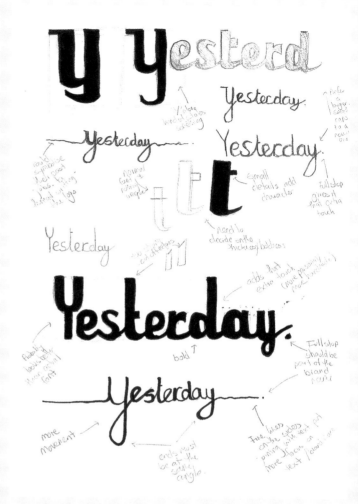

**Above:** Practice makes perfect. Only
through regularly undertaking this
process will your skills and confidence
develop. This stage also allows time for
personal analysis and reflection, which
can be recorded in a way that is not
possible on a computer.

**Opposite, top:** Graphite came into
widespread use following the discovery
of a large graphite deposit in
Borrowdale, England, in 1564, and
the first mass-produced pencils were
manufactured in Germany in 1662.
It is perhaps still the designer's best –
and simplest – tool.

**Opposite, centre:** Taking advantage of the
'erasability' of a pencil to define an initial
idea, and then confirming the line with a
marker by tracing over the sketch, is a
highly effective way to develop initial type
concepts.

**Opposite, bottom:** This concept sheet
demonstrates the various stages of building
a marker rendering sketch. Starting with a
rough pencil outline, 'washes' of marker
build up tonal variation, highlighting light
and shade.

# Drawing techniques

Line-weight drawing is a technique that gives different 'weights' – darkness or heaviness – to a line. This is achieved by the amount of pressure applied at the point of the drawing tool, the size of the nib or the angle used. Traditional graphite pencils come in a wide variety of hardnesses, the grade symbolized by a letter and number usually given on the side of each pencil ('H' for hard, ranging through 'HB' in the middle, to soft – 'B', or 'black' – at the other end). The higher the number in front of these letters, the harder or softer the pencil. Line-weight drawing can be employed, for example, to highlight the importance of a line, define the direction of light or give prominence to things in the foreground. Fineliner markers are perhaps the most common tool used to achieve a variety of line definitions. In most drawings, applying at least three different weights will give a sketch energy and dynamism.

Marker pens are widely used for drawing as they have a spontaneity and directness of application that can produce a wide range of effects. Their ink is semi-transparent, so colour intensity can be built up in layers, allowing for the mixing of colours and the addition of darker tones and shadows. There are two main types of pen: solvent-based and water-soluble, and they all come in a variety of nib sizes. A type of paper is made specifically for this medium, similar to layout paper but designed to prevent bleed.

There are two basic styles of marker drawing. The first is used for quick layouts and concepts, where the marker stroke is visible. The second comprises finished visuals, where the strokes are blended into flat areas of colour to give a more polished effect. The main aim of this type of visualization is to capture light and shade, modelling form with simplified tones, although markers can also be used simply to add colour or shadows to a type concept.

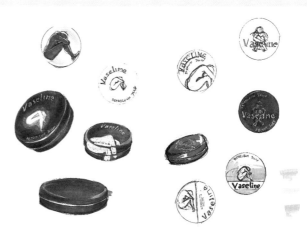

Lightboxes are often used with layout paper to trace and develop an early sketch into a more finished idea. This enables an early sketch to be developed into a more finished concept, which can be quicker than completely redrawing the original idea. In a similar way, an initial pencil sketch can be worked up using fine liners without the need to rub out any of the original drawing.

Cut and paste is a particularly effective technique, used to develop a wide range of ideas in a short space of time. Elements such as brand marks or labels for packaging can be photocopied numerous times, cut and then pasted onto concept sheets where additional elements can then be developed around them, thus speeding up the concept process.

A combination of techniques can also be a quick and effective way to capture a concept. Here the type is printed in various sizes and layouts, and then cut and pasted into a fine liner sketch with marker shadows.

# TIPS & TRICKS
## How to reference and credit sources

Developing the habit of always referencing sources may save hours of searching later on in a project. Maintaining a professional and ethical approach is important, as is safeguarding against accusations of plagiarism. One of the most commonly used referencing methods is the Harvard system (used here). Whatever system you use, the important thing is that it is used consistently.

### Books
Barry, Peter. 1995. *Beginning Theory*. Manchester: Manchester University Press

### Websites, blogs and Twitter
Smith, John. (2012). *A Story About Art*. [Online]. BBC Website. Available at: http://www.bbc.co.uk/news/99_43_33.htm. [Accessed: 20 August 2013]

### Music track from an album
Gray, David. 1998. 'Babylon' on *White Ladder*. London, IHT Records

### Images and illustrations
*Women of Britain say 'GO!'* (1915) [Poster] Available at: http://www.vads.ac.uk/collections/IWMPC.html [Accessed: 25 February 2013]

*Façade of a house* [Oil painting] In: Comini, Alessandra. *Egon Schiele*. Plate 43. London: Thames & Hudson

### Photography
Walker, Spike. (2003) Dandelion Flower Bud [Photograph; Transverse section through flower (inflorescence) bud of dandelion, viewed with a light microscope, solarized.] Available at: http://images.wellcome.ac.uk [Accessed: 24 June 2009]

# ORGANIZING YOUR SOURCE MATERIAL

Keeping sketchbooks, scrapbooks or journals is a habit that should be maintained throughout a creative individual's lifetime; these do not necessarily have to be connected to any one specific project. Sourcebooks provide a neat place to store ideas and inspiration, and they can be referred back to easily at any time. Traditionally they were created by cutting and sticking found materials and images into a book and making notes. However, it is now easy to store and organize any digital material on a computer, and this archive can and should be used to complement any physical sourcebooks.

There are now also online systems that will sort and collate this material for you, such as Pinterest, which enables members to share media by 'pinning' images, videos and other objects. For designers, a key feature of the site is the opportunity to create 'boards' where pins can be organized by topic, such as 'brand icons' or 'hand-made type'. Boards can be public (allowing teams to invite each other to pin, view and share inspirational material) or secret (ideal for designers working on projects for sensitive clients).

Blogs, such as those found on Tumblr, can also be an effective way to capture inspiration and make comments and analysis. This microblogging platform allows the user to post multimedia and other image content to a short-form blog. Users are able to follow others' blogs, and can maintain privacy for their own blogs if needed. Tags are perhaps one of the most useful features of this site, as they allow the user to create tags linked to each post to aid navigation among similar content.

Whatever system is used, however, there are some key techniques that can make what could simply be described as a 'scrapbook', whether real or virtual, into a useful design tool. These include referencing the source of images or materials. It is always important to remember that although images appear to be freely available on the Internet, if they are to be reproduced in a professional context, the permission of the creator must be sought and relevant fees paid for their use. When collecting images, proper referencing also reminds a designer of where to find the original source.

How the images are presented can also aid in the usefulness of a sketchbook. Making them aesthetically pleasing can make sharing them with colleagues less likely to cause embarrassment, and for students this type of personal research will often be requested as part of an assessed project. If care is taken in the design and layout of these books, they can surpass the status of mere scrapbook and become beautiful objects in their own right.

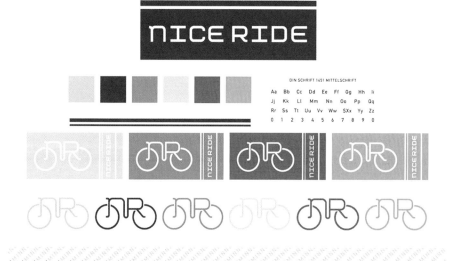

NICE RIDE

DIN SCHRIFT 1451 MITTELSCHRIFT

Aa Bb Cc Dd Ee Ff Gg Hh Ii
Jj Kk Ll Mm Nn Oo Pp Qq
Rr Ss Tt Uu Vv Ww SXx Yy Zz
0 1 2 3 4 5 6 7 8 9 0

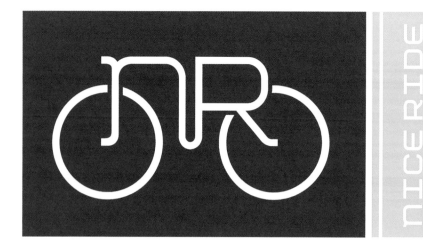

An example of the final solution for a brand identity designed for a bike-sharing initiative. The artwork presented to the client must convey all the options that the design team has created for the brand, including colour variants, the brand logotype and the brand icon.

# CHAPTER 8: DELIVERING THE FINAL DESIGN

Chapter 7 explored the first stages of the creative brand design process and how to develop a range of initial concepts. This concluding chapter outlines the delivery of the final design solution, with information on how to identify the strongest solutions, ensuring that the concepts are appropriate as well as creative, and how to communicate these to the client in a professional and effective manner.

# CHOOSING THE BEST CONCEPT

Developing a wide range of design solutions is useful for the design team in the earlier stages of creating a new brand identity, but these ideas will need to be edited down for the final presentation to the client. Too many solutions at this point will only cause confusion.

Knowing which ideas are the strongest can be difficult. Within a professional design team these judgements are made on a daily basis, as the designers have to respond to tight commercial deadlines. In many cases it is the lead designer or senior creative who has the last word on which of the ideas should be moved forward to the next phase of development. Having a fresh pair of eyes to review the concepts ensures that ideas are chosen based on their appropriateness to the original brief rather than a personal attachment.

In a professional studio, for instance, with three designers working on developing initial ideas, many tens of concepts may be created. Informal discussions often take place between the individual designers on the subject of how to generate new and stronger solutions. These early ideas are then assessed in a more formal way by the senior creative. The number of ideas to be taken forward will also depend on the delivery deadline and the allocated budget.

The brand identity solutions created by the team will include a unique name (defined by a carefully chosen typeface or a hand-crafted logotype), a brand mark or small image, a strapline or tagline (slogan) and a colour palette. The senior creative in the team will assess the success of the ideas by referring back to the original brief, which will have been broken down into key areas as described in Chapter 6 (see page 123). An assessment also needs to be made of the uniqueness of each idea relative

## Creative concepts

Exploring a range of exciting names and pack designs to fit each platform

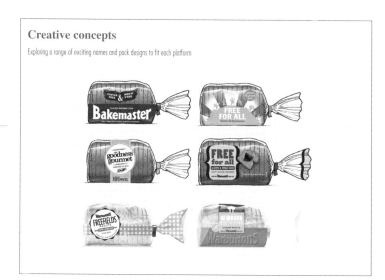

## Concept development

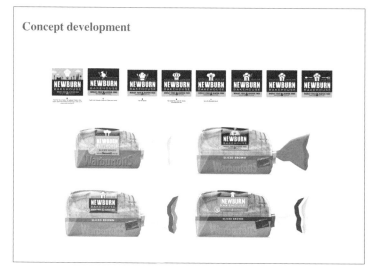

**Top:** These creative concepts designed by Dragon Rouge for Warburtons bread, demonstrate a range of ideas developed to explore different approaches; each design is unique.

**Above:** The concept development example for the same project shows how the next phase involves reducing the approach to a few key ideas that are then developed even further.

to any of the brand's competition. Finally, analysis will be undertaken in order to understand how well the design communicates the USP that has been defined for the new brand to ensure that it stands out from the crowd.

**EXERCISE**

## Creative concepts
Lead creative and brand identity concept

## First packs off the press

## Brand equity toolbox

**Top and centre:** These first two images are examples of the creative concepts designed by Dragon Rouge to show the 'lead' brand concept for Organix, demonstrating how the identity would appear on a range of flavour variants.

**Above:** In addition to the pack visuals, the team has also created a 'brand equity toolbox' that explores all the separate elements designed for the new identity. The next phase involves testing the final design against the original brief.

# How to develop an assessment strategy

In an educational environment it is often at this stage that lecturers step in to act as the senior creative, critiquing ideas to help students define the strongest solution. However, developing a personal strategy to assess the success of concepts will enable you to strengthen your own critical analysis abilities. Having a clear process that will quantify how well the creative outcomes answer the original brief will also demonstrate objectivity and critical awareness, and ensure that the final choice of concept is not based purely on personal preference.

Start by interrogating the brief. What is the creative problem that is being set? Who is the target consumer? What is the product or service being communicated? These key areas need to have been addressed in each of the concepts developed. With these in mind, the success of each individual idea can be judged. Making an assessment table (like the one here) can highlight how well a design meets the requirements, and will ensure that the results can be easily interpreted.

| Assessment criteria | 1 | 2 | 3 | 4 | 5 |
|---|---|---|---|---|---|
| How well does the design communicate to the consumer or audience? | | | | | |
| How successfully does the design communicate the product or service being branded? | | | | | |
| How clearly does the design reflect the USP? | | | | | |
| How strongly does the design stand out from its competition? | | | | | |
| How well does the design communicate the market position or price point? | | | | | |
| How effectively does the design capture the tone of voice? | | | | | |
| How creative or unique is the design? | | | | | |

# FINAL
# REFINEMENTS

Once the concepts have been checked against the assessment criteria, a shortlist of the three strongest ideas should be chosen. It is imperative that these concepts demonstrate a range of thoughts and approaches, and they should define three distinct and unique identities. The selection of these may often be based on a 'mild to wild' or 'evolutionary to revolutionary' scale (see page 124). Offering one idea to a client is never advisable – if it is rejected the creative team will have no fallback position.

The final designs are refined to ensure that any areas of weakness identified during the assessment process are rectified. This will usually involve small tweaks rather than complete redesigns. All creative solutions at this stage of the design process are computer rendered. Most commonly designers use the Adobe Creative Cloud package including applications such as Photoshop, Illustrator and InDesign to artwork their concepts.

Particular things to consider at this stage might be: the quality of typography; the layout and spacing of the letters (leading and kerning); a refinement of the colour palette; the polishing of any images; and the overall balance of all the elements used within the identity. Finally, tests need to be done to ensure the brand's name will be legible when the design is reproduced at a small scale, on screen and in other relevant environments.

**Top:** Even small tweaks to the final design of a brand identity can make a significant difference. This example shows the addition of a link between the 'O' and 'R', giving the centre of the typography more strength and personality.

**Above:** The final polishing of this identity demonstrates the care the designer is taking in ensuring that every angle on both the brand icon and typography is the same. This will give the identity greater cohesion between the various elements.

# PRESENTATION MATERIALS

Within the industry the presentation of the final design to the client is perhaps the most critical stage of a project. It is at this point that the creative team can demonstrate their level of design thinking and creativity. Ensuring that the idea is 'sold' effectively demands strong verbal and visual presentation skills to highlight how well it answers the original brief. This is also the time when the design team will be expected to explain the pricing, project management and business protocol for the brand project.

Crucial to this stage is a clear communication strategy, usually involving a set of visuals of the final designs. These 'communication boards', as they are sometimes known, demonstrate to the client the success of the final design solution in answering the original problem set by the brief. Traditionally these boards were printed pages mounted on presentation board, but agencies today are more likely to use digital presentation soft- and hardware to create digital images (see page 147).

Key elements included in the communication strategy depend on the original brief set by the client, but will usually include designed elements such as the brand mark or logotype, showing the chosen typeface; use of colour; a brand icon; strapline; and any brand accessories and graphics or brand standards. Also presented will be the elements that demonstrate how the brand will be reproduced, which could include advertising, packaging, print (such as brochures), websites, social media, apps, retail environments and marketing materials. Other points may also be visualized for the client, including demonstrating the success of the brand in communicating to the target audience, and how well the brand works in specific environments.

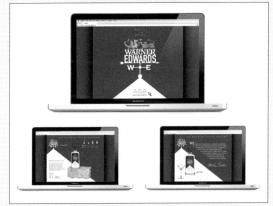

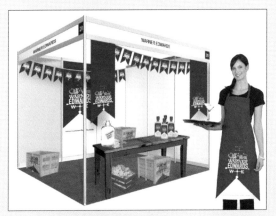

The communication boards created for Bluemarlin's presentation to their client Warner Edwards (see page 116) included the brand identity, colour palette and branded packaging, as well as a range of other promotional materials.

The identity was shown expressed as stationery, a website and a branded show stand. The visuals allowed the client to appreciate the strength and flexibility of the design, enabling it to communicate across a range of communication media.

# DESIGNING EFFECTIVE COMMUNICATION BOARDS

Firstly, consider what elements are necessary to demonstrate the success of the final brand. When designing the layout of the boards, it is helpful to group together relevant pieces of design to ensure clarity of communication. For example, use one board to show the key designed elements such as the brand, the brand icon and strapline, and a separate board to show how the brand would appear in digital formats or retail environments. Keep the layout simple; too much information on one board can be confusing. The style, choice of typeface and layout of the boards need to be considered with the same amount of care as the elements being presented, as the final presentation needs to demonstrate the professionalism of all your graphics skills.

Add headings and sub-headings to the boards to help identify the elements being presented. It is important to remember that some clients may be new to working with designers, so leading them through the process step-by-step will help them appreciate what has been designed and why. In an educational environment this approach will also demonstrate the strength of a student's skills, understanding and depth of knowledge – an important consideration when the project is to be assessed.

The following points will help to ensure the professional quality of a visual presentation:

- Keep the design of the boards simple, whether they are physical prints or a digital presentation. Do not add any additional elements such as decorative borders or backgrounds – these will only be a distraction.
- Do not be afraid of negative space. This helps give the images space to communicate.
- Give each board a clear strategy: what is being communicated and why? This can be communicated through titles for each board.
- Use a grid system to provide a layout theme that will link any separate boards.
- Use a limited colour palette, ensuring that it aids rather than fights the designs being communicated. If in doubt use neutral colours such as grey, black and white.
- Any images should be high resolution (at least 250 dpi) to avoid pixellation.
- Do not use any poor-quality photos or clip art, as this will detract from the professional quality of the presentation.
- Any type added as 'dialogue' on the boards must be kept minimal. It needs to be legible but must not overpower the design elements. Remember that text for digital presentations may need to be larger than for printed communication boards.
- Use the same typeface throughout, and one that does not conflict with the brand or branded elements being presented. Never use the brand typeface for any other elements on the boards.
- Check for grammatical errors, spelling mistakes and typos.
- Make sure every element on the boards works hard as part of the overall communication of the final brand solution. If any element is unnecessary, remove it, as it will only distract.
- Digital presentations should also be kept simple. Do not use distracting slide transitions or animated features, unless they are required to answer the brief or they add to the communication of the design being presented.

# DIGITAL VERSUS PRINT PRESENTATIONS

The creative industries, and brand design agencies in particular, always seek to work at the cutting edge of digital technology and use the most current software and presentation platforms available to communicate their ideas to their clients. However, it is important to remember that some digital visualization technologies can isolate or even 'alienate' the audience rather than engage them. The use of large vertical screens can be more inclusive than small-screen laptops, but they still force the audience to take a passive role in the presentation as there is no opportunity for interaction. Over the last few years technologies have advanced to enable a 'shared screen' experience where the furniture itself hosts the content through the use of 'digital tables'. Hardware and software from companies such as nsquared encourages all the participants to touch and explore the content simultaneously. In this way the conversation and content is shared by both designer and client, encouraging highly creative and immersive presentation experiences.

By contrast, adopting a low-tech approach and using communication boards allows the design team to connect with the people in the room on a more personal level rather than stare at the back of the presenter's head for the duration of the presentation.

Using a variety of methods is perhaps the best solution. It varies the client's experience and makes the meeting more dynamic. Sections of the presentation might be done on screen, with mock-ups of printed matter and, if appropriate, branded packaging available to view in physical form.

**Above:** Using a range of presentation methods, both digital and printed, helps to engage the client more fully. Sydney-based company nsquared integrate large digital tablets into table surfaces to facilitate communication, as seen in the top image.

**Below:** Prezi is cloud-based digital presentation software enabling creation, editing and presentations from browsers, desktops, iPads or iPhones, automatically syncing across all devices. Zoom in and out of the image to focus on the area of interest.

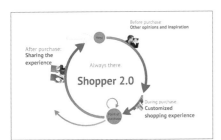

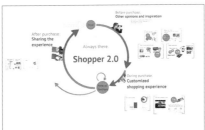

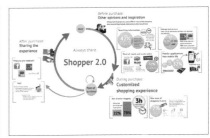

Finally, you might want to provide the client with something to take away at the end of the meeting to remind them of the key aspects of the agency's presentation. This could be in digital form (stored on a CD or other media) or a beautifully designed printed artefact, such as a brochure or book.

## Types of boards

There are three general types of boards that you will need to prepare for a presentation.

### Brand standards

The final brand and its architecture need to be clearly specified as a set of 'standards', which will include the size and font(s) chosen for the brand name and strapline; the spacing/kerning of the type; the size of the brand name in comparison to other type and the brand icon, if used; the size and placement of any brand icon; the Pantone, CMYK, spot and RGB colours used. The boards need to include the dos and don'ts allowed for the brand use by the original designer. These standards are useful for ensuring that all communications, internal and external, uphold the brand's design.

### Specification boards

These will confirm other specifications relating to the design – for instance, paper stocks chosen and any embossing, spot varnishing, die cutting or foil blocking used. In the case of branded packaging, details will be given of specific materials chosen. Specification boards will also include clear diagrams and images of three-dimensional shapes for bottles, boxes or any other designed elements created for the brand.

### Brand in context boards

When developing the final brand communication visuals, it is important to include the contexts in which the brand will be seen so that both the client and the designers can explore how the brand will work in real-life situations.

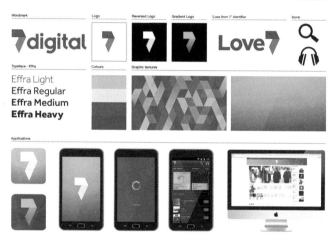

This range of presentation materials was created for 7digital by the design agency Moving Brands. The new identity needed to be flexible enough to perform across all communication platforms. The design team therefore created a brand concept book, a brand-in-context board and, finally, a 'brand bible' showing the brand standards.

# THE CLIENT PRESENTATION

The way a presentation is designed should be determined by the needs of the client. In many cases this may be digital; however, there is still a place for the traditional printed approach for some clients.

For the design team this can be an anxious time, as it is the point where often months of painstaking work are put to the test. It is therefore vital that the design solutions are presented in a professional manner. Many designers know, through bitter experience, that even some of their best and most creative ideas can be at best misunderstood by the client and at worst annihilated, if the meeting is not conducted effectively. For the client, too, this is a stressful time, as they have placed the responsibility for creating their new business opportunity in the hands of others and often paid considerable sums over many months leading up to this point.

In addition to the visual elements, consideration also needs to be given to the verbal and practical aspects of a presentation. For instance:

- How long has the client given for the meeting?
- Who will be attending?
- Where will the meeting be held?
- What facilities are available? (e.g. Internet access, projectors etc. – this is especially important if you are giving a digital presentation)

Understanding these practical issues will help the design team prepare appropriately for the meeting.

## Preparation

It takes time and experience to develop professional presentation skills, but good preparation will ensure you have the best chance possible of things going well. There are some basic approaches that will ensure the smooth management and delivery of the meeting:

- Practice in advance
- Organize any 'leave behind' materials for your client to take away

- Ensure that any question can be answered – on brand strategy, market research or design
- Develop an agreed agenda with the client to be circulated in advance, creating clear and agreed expectations
- Arrive early to organize the meeting room, to put both you and the client at ease
- Test all presentation equipment, lighting and ventilation before the meeting starts
- Stay focused, keep to the agenda and keep the meeting moving and on time

## Connecting with the client

A smooth and slick presentation should not be the design team's only goal. Perhaps one of the most important objectives for the design team or individual creative is the connection they make with the client during the presentation. It is vital to build trust so that the client will have confidence in the solutions being proposed for their brand.

Tom Leach, freelance creative previously of Partners and Imagination, highlights the importance of clear and simple communication:

> You need to build the story by presenting 'the big idea' bit by bit, removing where possible any subjectivity, until finally they understand that logically there really is no other solution …

Where jobs go wrong is when there is a lack of trust. Symptomatic of this problem is the client demanding hundreds of new solutions because they doubt your ideas.

Finally his tip to a successful client presentation is to ensure that you are absolutely convinced in your solution, as great work drives confidence, 'get excited, enthusiasm goes a very long way'.

Although the design process that has been explored throughout this book demonstrates how design agencies have been able to develop an almost scientific methodology to creating a brand identity, the final outcomes are, above all, visual and therefore appreciated in different ways by different people, depending on taste. However clear the brand strategy may be, or how professional the presentation is, this will not help you if you have based an entire design on lime green and you present this to a client with a strong personal dislike of that colour! An understanding of the client's past experience of working with designers can be crucial, therefore, for determining in advance the correct approach to take.

It is important, too, to remember that many people are not visually literate and can find making visual decisions difficult. It is therefore important to tailor the presentation to the level of the client and not to baffle them with inappropriate terminology. Many designers find that they have to guide their clients and support their understanding of the process in order to engage them fully in decision making.

The final decision as to which design is chosen is ultimately the client's; however, it is up to the design team to sell the idea that they feel is most effective. A client may also decide that there are elements from a number of the ideas that they feel could be incorporated into the final design solution. The team will then use this feedback to guide the final stages of the design process.

## Meeting strategies

Considering things from the client's position is key in developing a successful strategy for conducting the presentation. Here are some key points for ensuring clear and effective communication:

- Provide an overview of how the presentation will be organized, and in what order the information will be delivered. This will help to provide a clear overview and put the client at ease.

- Define the aims of the project, providing a review of the decisions made and clarification of the target audience, market sector and USP.

- Present each of the design solutions in turn. It is important that the client appreciates the unique qualities of each identity – what and how it communicates to the consumer, and why.

- Ensure that each of the solutions is provided with a real-life context to show its effectiveness in reality, such as on-pack or online advertising.

- Be ready to answer questions. Do not become trapped in a situation where the design needs to be defended – always have a clear, non-emotional answer to any question that highlights the strategy underpinning each design. Avoid becoming trapped in discussions of aesthetics; return to the original strategy to define market and consumer appropriateness and appeal.

Taking the time to consider the best presentation strategy ensures that the client appreciates not only the quality of the final design, and its effectiveness in communicating the brand values, but also the time and effort it has taken to get it right!

- Be convincing. This is difficult if there is no personal conviction, though – if the designer does not believe in the solution it is likely that this will be communicated to the client.

- Have a strategy for the next step. Always offer the client more than they are expecting. Going that extra mile demonstrates conviction and commitment to the project.

- Take minutes. Ensure that someone records the client's comments, suggestions and decisions. The whole process will be pointless if these are forgotten or not remembered correctly. The client's final decisions must be carefully noted.

- Agree on the next stage. It is vital that the conclusions of the meeting are understood, and that the client agrees with what the next phase of the process will be. This can either be defined at the end of the meeting or undertaken in a more formal way, by email or letter. It is important to receive the client's final approval before starting the next phase.

## TIPS & TRICKS

For many designers (and especially students), time management can play an important role in how successfully they manage to develop their final ideas, ensuring that they have the polish expected of a professional piece of work. A useful tip is to design a timetable, using the step-by-step process highlighted in Chapter 4 as a guide. Without careful crafting and attention to detail, your final brand identity may look unconsidered and rushed.

# TESTING THE FINAL BRAND IDENTITY

After a client has approved a design or branding strategy, there are a number of further steps that must be taken before the brand can be launched.

## The trademarking process

An agency is responsible for checking that there are no issues concerning conflicts with existing brand marks. This work is usually undertaken by an intellectual property firm engaged to work on the trademarking process. Once the uniqueness of the new brand has been confirmed and no issues with existing brands have been identified, it can then be trademarked.

All parts of the final brand can be trademarked, including names, symbols, unique typefaces, straplines, product design, packaging, colour and sonic branding. A legally registered trademark is identified by the small ® symbol next to it, and enjoys several benefits:

- A trademark makes it easier to take legal action against anyone who uses the brand without permission
- Trading Standards officers or the police can bring criminal charges against counterfeiters if they use the brand
- The brand becomes the property of the holder of the trademark, which means it can be legally sold, franchised or licensed to allow others to use it

Applying for a trademark is a reasonably cheap and generally uncomplicated process. For more information on how to apply for a trademark in the UK go online to the UK Intellectual Property Office at www.ipo.gov.uk. In the US contact the United States Patent and Trademark Office (www.uspto.gov).

# DESIGN DEVELOPMENT

Once the client has added their thoughts and opinions, the final design is produced. This is, however, more than a 'tweaking' process as this phase requires the designers to work at an obsessive level of detail to refine the final design solution. All applications of the brand need to be identified by the client and passed to the creative team, and any additional communication elements developed. The final design will then be returned to the client for the final sign-off.

Although this is the final creative stage of the brand development process, it is not the end of the relationship between the client and agency. In order to make certain that the brand is successfully applied and marketed, the design team is often commissioned to manage the final stages to brand launch. In some cases, these responsibilities also continue after launch to 'police' the appropriate application of the brand, or to readjust and tweak it in order to ensure its final success.

## Client confidentiality

Although it is vital that the final brand identity is tested, these tests must be done with considerable secrecy. Many projects are protected by non-disclosure agreements, or confidentiality agreements – used to protect valuable information. Typically, non-disclosure agreements are used in circumstances where one party wishes to disclose valuable information to another, while at the same time protecting the information from unauthorized use or disclosure to others. A couple of well-known examples of this sort of confidential information – 'trade secrets' – are the recipes for KFC chicken and Coca-Cola.

Design agencies and individual designers will often have to sign this type of contract when working on sensitive branding material, to reassure clients that none of their new corporate strategies will be revealed to their competitors before the project is completed. Students on work experience can also be expected to sign this type of contract if they are given the chance to be involved in large client projects. These contracts may also apply to individuals involved in market research tests.

## Market research

This stage is used by the client and design agency to ensure that the design uses effective brand communication to 'speak' to the consumer. Testing also avoids costly mistakes or delays in bringing a new brand or rebranded product to market. Ways of testing designs or brand identities may include focus groups (see page 96) and questionnaires, perhaps asking consumers to rate the image of a brand on a numbered scale.

Criteria applied in testing a final brand design include:

How strong is the identity? Does it offer impact or shelf presence?

How flexible is the identity? What is its size and application on different communication materials? Is it still legible at a small scale?

How effective is it in communicating the brand's values and USP? Does it look like what it does?

Is it culturally sensitive? In our modern global market, brands need to be promoted effectively both nationally and internationally.

Do all the elements of the brand identity work together effectively? Do the brand icon, typeface and strapline type work holistically and sit comfortably together?

Will it animate? Most brands now have a presence where there is a possibility for animation, via the Internet or broadcasting, so this may be an issue for the brand communication.

How well will the brand be able to extend? Brand extensions are a well-understood way to develop an existing consumer base, therefore building this opportunity into a new brand from the start – 'future-proofing' it – will provide further longevity. How well will the brand work in five or ten years' time?

Conventional focus group testing can be expensive and time-consuming, but techniques such as A-B testing on social media offer a new alternative. Perhaps the design team has arrived at two strong brand logos and you are not sure which one will produce the best response from the consumer. Instead of following the conventional focus group route, you can test a design by asking the consumers who are already fans of the product or service. People who have liked a brand's page on Facebook or followed a brand on Twitter are more likely to provide you with honest, useful answers.

This enables the design team to gain insights and to make adjustments to the brand design based on the preferences, comments and reactions of the intended audience. For the client, this approach can alleviate any fears about launching a new brand or rebrand as they will know exactly how the market will react. This feedback will then provide the last elements needed by the creative team to complete the final designs.

A good example of the sort of practical research used to determine the success of a final design was undertaken for a large organic-foods manufacturer by the American strategic research company, Decision Analyst. The challenge was to identify the optimal combination of brand name, product form and packaging for a new range of organic children's meals targeted at mothers with young children. A new child-focused brand name and innovative packaging that would make the product more fun and convenient as well as generating strong shelf impact had already been created, however the client wished to launch the new identity in the most successful way. The primary objective of the research was to explore value perceptions defined by the visual language created for the brand by determining the most promising concept in terms of consumer acceptance.

The research method applied was to recruit mothers with young children through the company's American Consumer Opinion online panel, the 200 qualified respondents being primarily grocery shoppers and recent purchasers of this category of food. Each respondent was shown one concept, including a product illustration and description, and asked to complete an online questionnaire to record their reactions. The concepts tested included all the combinations of variables for production formulation (original and healthier), packaging (traditional and new), and brand names (the current 'flagship' brand name and the new 'child-oriented' brand name).

The results of the research revealed that the concept that featured the combination of new packaging, healthier formulation and the new child-focused brand name was the most favoured by all the mothers. This concept therefore generated the highest sales potential in relation to the suggested purchase price.

The case study illustrates how well-designed and carefully executed market research study can aid both client and designer in testing the success of a new identity before making the costly decision to launch a new product. In addition, the study also reveals important information about the buying decisions of young mums and what compelling factors drive their purchasing decisions.

## Final polishing

This is usually the final stage undertaken by the design agency, involving integrating any changes that have arisen and responding to feedback gained during testing. The team will then hand over the final designs to the client. In some cases, however, the team may also be engaged to be part of the brand launch, creating the elements defined by the communication strategy.

# LAUNCHING THE BRAND IDENTITY

The launch strategy for a new brand will ultimately depend on the type of product or service that it represents. In the case of a new brand this can be a considerable undertaking as it may be launched across a whole host of different communication media, including building exteriors, interiors, exterior signage, vehicles, uniforms, and marketing and advertising materials, as well as online presences such as websites and social media.

It is important to remember that the launch of a new brand is not purely a marketing exercise. A new brand may also mean new employees who have been recruited to make the brand 'work'. Creating an internal brand strategy (see page 34) is a key stage in the rolling out of the new identity, and is undertaken well in advance of the promotional and marketing strategy aimed at target consumers or audiences. Ensuring that the team have a clear appreciation of the brand's values, its equity, and how it differentiates itself from the competition and speaks to its audience is vital if the new brand is to succeed. Employees may require training in understanding the new brand identity – how it should be used, what it means and why it matters. The challenge is to make them believe in it and become emotionally connected to it.

A great example of a well-executed rebranding launch was demonstrated by the company CSC, a business solutions service who worked hard to help their new team understand their roles and learn to 'live' the brand. The company had created a comprehensive website, the CSC Style Guide, that offered all the information internal and external audiences needed in order to understand and use the CSC brand identity. The internal section of the website is available to employees only and requires employee login to access it. CSC took the time to understand how important internal 'buy in' is to its

Launching a new brand identity and then keeping it fresh in the minds of the consumer ensures that a brand becomes integrated into the public consciousness.

The design team Duffy & Partners had a clear aim for the bike-share initiative Nice Ride Minnesota: to launch its distinctive branded lime-green bikes, and to create a range of branded promotional materials, including T-shirts and posters.

As additional promotion, they placed Nice Ride bikes, encased in blocks of ice, in strategic city locations. As the weather warmed, the blocks melted, eventually releasing the bikes and heralding the launch of Nice Ride season.

# BEYOND DELIVERY

brand success, and invested time and money in providing easy-to-access information and educational tools.

Once the internal brand exercise is complete, the more obvious external roll-out can start, targeting new markets and consumers. Depending on the type of brand being launched, this may involve traditional communication materials, although more and more brands are appreciating the power of new media and communication platforms.

For example, in 2009, when AOL separated from Time Warner, the company launched a new logo along with a preview video that they debuted on their own unique AOL Brand Identity YouTube channel one month before the new brand identity was officially launched. The video not only introduced the new logo, it also made it clear that the new AOL image would be a far cry from its previous identity. This 'brand' new identity was trendy, modern and young. It was a highly successful rebranding exercise.

In the contemporary world, where new technologies mean that communication is instant, and new trends and ways of thinking can travel around the world almost as quickly, embracing change is vital if a brand is to survive into the future.

Social media in particular provides more access to conversations, opinions, commentary and complaints, impacting on brands in ways that were once inconceivable, with opportunities for great gains lurking beside the potential for catastrophe.

By undertaking careful monitoring of markets and media, new opportunities can be presented and identified that can enable a brand to steal a march on its competitors. But if a brand is not watching and listening, the competition will likely get there first: complacency is the forerunner to extinction. Market research – as outlined in this book – remains more crucial than ever, though for many brands it has evolved into a continuous, daily activity.

Twitter, Facebook, LinkedIn, blogs, forums and videos can all be used to link with 24-hour consumer touchpoint experiences, which can be hugely advantageous to the ongoing health of a brand. Not only can a company create its own opportunities, it can also join conversations, nudge them in the right direction and correct erroneous complaints. By engaging with consumers, it can bring the brand to life.

Better connected consumers are also better informed, more agile, less trusting and from a brand's perspective, more fickle: they will drop one brand in favour of another if they feel they will get a better service or value for money. Staying in position therefore requires a brand to constantly research, monitor and listen to what their consumers want because, ultimately, brands are not about companies, they are about people.

# Glossary

**Alignment**
Occurs when the physical identity, emotional and philosophical values of the brand all support each other successfully.

**Alternative Marketing**
Uses new or innovative methods to promote a brand. These can include social networking, viral campaigns, pop-up experiences and word of mouth.

**Brand**
A set of elements, both physical and emotional, used to evoke a desired response in the minds of consumers or audiences. The aim of branding is to create a unique identity to differentiate a product or service from its competitors. A brand usually includes a range of designed elements, including a name and a distinctive visual style.

**Brand Architecture**
This can mean either the organization and structure of a single brand, created through a designed system of visual elements, or else a system of related brands exploring the relationship between a parent company and its products and/or sibling brands.

**Brand Attributes**
The associations, either functional or emotional, that an audience or consumer assigns to a brand, either negative or positive.

**Brand Audit**
A comprehensive and systematic examination of a brand's communication and marketing strategy.

**Brand Awareness**
The ability and speed at which customers recognize a brand's name, logo and unique point of difference.

**Brand Equity**
A measure of the value of a brand, this can be determined in two ways. One is by examining the tangible assets (patents, trademarks) and intangible assets (differentiating qualities) that contribute to the value of the brand. Alternatively, it is the financial premium derived from loyal consumers willing to pay more for a branded item or service.

**Brand Essence**
The distillation of a brand's core values into a simple, succinct concept that is fundamentally rooted in customer need.

**Brand Extension**
The expansion of a brand through the creation of a new product or service. This usually entails leveraging the brand's existing value in order to enhance the consumer's perception of the new offer.

**Brand Guidelines**
*See Brand Standards*

**Brand Identity**
A unique set of designed elements that identifies the brand and expresses the brand promise including the name, type, logo/symbols, icons and colours.

**Brand Loyalty**
A measure of the strength of consumer preference for a particular brand.

**Brand Management**
The job of ensuring that the tangible and intangible aspects of the brand remain consistent.

**Brand Mark**
Also known as a logo or brand icon. It is a symbol or design element that allows consumers to identify a specific brand and differentiate it from others. *See also Logo*

**Brand Message**
The primary statement used to express the brand promise, reflecting the desired personality and position of the brand.

**Brand Personality**
The brand expressed in terms of human characteristics (e.g. power, caring, purity). A way to personify the brand message, this application of human attributes is used to achieve brand differentiation.

**Brand Position**
The distinctive position created for an offering that ensures clear identification and differentiation by consumers.

**Brand Promise**
A statement capturing a brand's unique offer to its consumers. It highlights the brand's unique selling point and defines its position in the market, differentiating that brand from its competition.

**Brand Repositioning**
Developing a strategy to move a brand to a new market position. *See also Rebranding*

**Brand Standards**
Also known as 'Brand Guidelines'. A document or manual exploring in detail the design elements that constitute the brand identity, specifying typefaces, colours and visual elements. It also includes how to apply the brand appropriately.

**Brand Strategy**
The plan created after research into markets, consumers and competitors, used to guide designers when creating a new brand identity. It highlights the competitive advantages by defining the unique factors identified for the brand.

**Brand Tribe**
A group of people linked by a shared belief around a brand. Its members are not simple consumers, as their passion for the brand differentiates them.

**Brand Value**
*See also Brand Equity*

**Branded Environment**
The brand identity when applied to a three–dimensional physical space, typically a retail environment.

**Branding**
The process used by a company or organization to express its brand promise to a particular target audience, which conditions that audience to prefer the given offer. This is achieved by manipulating the tangible and intangible attributes that form the brand into a range of communication solutions.

**Colour Palette**
A set of colours created by a designer that expresses the qualities of the brand. These are then specified in the 'brand standards' to be applied throughout the brand identity.

**Demographics**
Statistical data showing variables within a population, e.g. age, gender, income level. Often used to guide research into market segmentation. *See also Psychographics*

**Design Strategy**
An outline of the design decisions made to define a brand's aesthetic. Used in brand creation and 'policing', it ensures consistent application of the identity across all communication solutions.

**Differentiation**
The distinct and unique characteristics that differentiate a brand from its competitors within the same category to give a competitive advantage.

**Emotional Branding**
The process of building brand value by creating an emotional connection between the intended consumer and the product or service.

**Family Brand**
A brand that has been extended through a family of offerings. Often shown through a visual relationship between the separate identities.

**Global Brand**
A brand operating internationally, such as Coca-Cola.

**Logo**
A unique symbol or design used as an identifying mark representing a brand. *See also Brand Mark*

**Logotype**
A custom typeface used to highlight the unique characteristics of the brand, sometimes trademarked, to be used only by the brand.

**Market Segmentation**
A strategy that divides a broad market into sub-sets of consumers with common needs and priorities.

**Niche Marketing**
Considering and fulfilling the needs, wishes and expectations of a small, defined groups of consumers.

**Parent Brand**
A brand that acts as an endorsement to one or more sub-brands within a range.

**Point-of-Sale**
A marketing display that presents a product with additional information about the offer explaining the benefits. Also know as point-of-purchase.

**Premium Brand**
A brand that is known to hold greater brand value than its competitors.

**Psychographics**
A market segmentation process that creates groups of customers according to their lifestyles, social class and personality. Used to explore patterns of purchasing. *See also Demographics*

**Rebranding**
The revising of brand communication with the purpose of refocusing or updating an identity in response to internal or external forces such as new market forces. *See also Brand Repositioning*

**Semiotics**
The study of symbolism and how people interpret meaning from words, sounds and pictures. In branding semiotics is used in the development of meaning in identity systems.

**Strap Line**
*See Tagline*

**Tagline**
A short descriptor linked with the brand name. Its function is to define a brand position.

**Visual Identity**
The sum total of the brand's visual aesthetic, comprising logos, logotypes, symbols, colours etc.

# Recommended Reading

### Books on Brand Theory

Ind, Nicholas. *Living the Brand: How to Transform Every Member of Your Organization into a Brand Champion*, Kogan Page (2007)

Macnab, Maggie. *Decoding Design: Understanding and Using Symbols in Visual Communication*, HOW Books (2008)

Olins, Wally. *Brand New: The Shape of Brands to Come*, Thames & Hudson (2014)

Pavitt, Jane. *Brand.New*, V&A Publishing (2014)

Roberts, Kevin. *Lovemarks: The Future Beyond Brands*, PowerHouse Books (2006)

### Books on Practical Branding

Airey, David. *Logo Design Love: A Guide to Creating Iconic Brand Identities (Voices That Matter)*, New Riders (2009)

Evamy Michael. *Logotype*, Laurence King (2012)

Gardner, Bill. *LogoLounge 4: 2,000 International Identities by Leading Designers* (illustrated edition), Rockport Publishers (2008)

Hardy, Gareth. *Smashing Logo Design: The Art of Creating Visual Identities* (Smashing Magazine Book Series), John Wiley & Sons (2011)

Hyland, Angus. *Symbol* (mini), Laurence King (2014)

Middleton, Simon. *Build a Brand in 30 Days: With Simon Middleton, the Brand Strategy Guru*, Capstone (2010)

Rivers, Charlotte. *Handmade Type Workshop: Techniques for Creating Original Characters and Digital Fonts*, Thames & Hudson (2011)

Wheeler, Alina. *Designing Brand Identity: An Essential Guide for the Whole Branding Team*. John Wiley & Sons (2012)

### Books for Inspiration

Fowkes, Alex. *Drawing Type: An Introduction to Illustrating Letterforms*, Rockport (2014)

Heller, Steven. *Typography Sketchbooks*, Thames & Hudson (2012)

Ingledew, John. *The A-Z of Visual Ideas: How to Solve any Creative Brief*, Laurence King (2011)

McAlhone Beryl, Stuart David. *A Smile in the Mind: Witty Thinking in Graphic Design* (new edition), Phaidon Press (1998)

Rothenstein, Julian and Mel Gooding (eds.). *Alphabets & Other Signs*, Shambhala Publications (1993)

### Books on Theory

Lury, Celia. *Consumer Culture*, Polity Press (2011)

Slater, Don. *Consumer Culture and Modernity*, Polity Press (1998)

Sternberg, Robert J. *The Nature Of Creativity*, Cambridge University Press (1988)

Wallas, Graham. *The Art of Thought*, Solis Press (2014)

Watkinson, Matt. *The Ten Principles Behind Great Customer Experiences*, FT Publishing International (2013)

### Books on Professional Practice

Airey, David. *Work for Money, Design for Love: Answers to the Most Frequently Asked Questions About Starting and Running a Successful Design Business* (Voices That Matter), New Riders (2012)

de Soto, Drew. *Know Your Onions: Graphic Design: How to Think Like a Creative, Act Like a Businessman and Design Like a God*, BIS Publishers (2014)

Moross, Kate. *Make Your Own Luck: A DIY Attitude to Graphic Design and Illustration*, Prestel (2014)

Shaughnessy, Adrian. *How to be a Graphic Designer, Without Losing Your Soul* (second edition), Laurence King (2010)

Shaughnessy, Adrian. *Studio Culture: The secret life of the graphic design studio*, Unit Editions (2009)

### Websites

### Brand Blogs

Brand Flakes – www.brandflakesforbreakfast.com/

Seth Godin – www.sethgodin.typepad.com/

Viget – www.viget.com/blogs

### Brand News

Brand Channel – www.brandchannel.com/home/

Branding Magazine – www.www.brandingmagazine.com/

Design Week – www.designweek.co.uk/

### Cultural Design

www.creativeroots.org

twitter.com/creativeroots

www.australiaproject.com/reference.html

www.designmadeingermany.de/

www.packagingoftheworld.com

### Inspiration

Its Nice That – www.itsnicethat.com/

Niice – www.niice.co/

Pinterest – www.uk.pinterest.com/

# Index

# Picture Credits

**T** = Top; **B** = Bottom; **C** = Centre; **L** = Left; **R** = Right

**BACK COVER**: Branding: Kokoro & Moi; Interior Design: Koko 3
**7** © Paul Souders/Corbis; **8** Image Courtesy of The Advertising Archives;
**9** iStock © Mlenny; **10** Courtesy BMW; **12L** Paul Vinten / Shutterstock.com;
**12R** iStock © BrandyTaylor; **13** iStock © winhorse; **16** Courtesy Soprintendenza
per i Beni Archeologici dell'Emilia-Romagna, Bologna, by licence of the Ministry
of Cultural Heritage and Activities, Italy; **17TL** Image Courtesy of The
Advertising Archives; **17TR** Image Courtesy of The Advertising Archives;
**17BL** © Heritage Images/Glowimages.com; **17BR** © Heritage Images/
Glowimages.com; **19** ©2015 The Clorox Company. Reprinted with permission.
CLOROX is a registered trademark of The Clorox Company and is used with
permission.; **20** Design Tomás Alonso, Photo by Gonzalo Gómez Gándara;
**21** Created by Projector for UNIQLO Co. Ltd; **22** © Jacques Brinon/Pool/
Reuters/Corbis; **24BL** ArtisticPhoto / Shutterstock.com; **24BC** Courtesy of The
Worshipful Company of Haberdashers; **24BR** © Nick Wheldon; **24TR** Courtesy
AB InBev UK Limited; **25TL** iStock © kaczka; **25TCL** © 1986 Panda Symbol
WWF – World Wide Fund For Nature (Formerly World Wildlife Fund) / ®
"WWF" is a WWF Registered Trademark; **25TCR** Courtesy BP Plc; **25TR** Image
courtesy of Toyota G-B PLC; **25CL** © General Electric company; **25CCL**
Reproduced with kind permission of Unilever PLC and group companies;
**25CCR** Designed by Pentagram Design Ltd; **25CR** Courtesy DuPont EMEA;
**25BL** © TiVo. TiVo's trademarks and copyrighted material are used by Laurence
King Publishing Ltd under license.; **25BC** innocent drinks; **25BR** Brooklyn
Museum logo designed by 2x4 inc.; **26** Courtesy Someone, Creative Directors
– Simon Manchipp and Gary Holt; Designers – Therese Severinsen, Karl Randall
and Lee Davies; **27** The Skywatch brand identity was developed by brand
architect Gabriel Ibarra. The website www.skywatchsite.com and retail
environments were created by Ferro Concrete. Images and files courtesy of I
Brands, LLC.; **29TL** innocent drinks; **29TR** Courtesy BMW; **29BL** Reproduced
courtesy of Volkswagen of America; **29CR** NIKE, Inc; **29BR** Courtesy of the
Hagley Museum and Library; **30** Photo courtesy Roundy's Inc.; **32T** Orla Kiely
(Pure); **32C** Orla Kiely (KMI); **32B** Orla Kiely (Li & Fung); **33T** BBC ONE, BBC
TWO, BBC three, BBC FOUR, BBC NEWS and BBC PARLIAMENT are trade
marks of the British Broadcasting Corporation and are used under licence.;
**33B** Courtesy Virgin Enterprises Limited; **34** BrandCulture Communications Pty
Ltd; **37** innocent drinks; **40** Hitomi Soeda/Getty Images; **42** ValeStock /
Shutterstock.com; **43T** iStock © evemilla; **43B** Plum Inc; **45** iStock © Yongyuan
Dai; **46T** © SSPL/Getty Images; **46B** iStock © Grafissimo; **47T** Neutrogena® is a
trademark of Johnson & Johnson Ltd. Used with permission.; **47B** Design:
Harcus Design, Client: Cocco Corporation; **48TL** iStock © PaulCowan;
**48TR** Stuart Monk / Shutterstock.com; **48BL** iStock © RASimon; **48BR** Courtesy
Mondelez International; **49** Courtesy Boston Public Library, Donaldson Brothers
/ N Y. Condensed Milk Co.; **50TL** From *Charlie and Lola: I Will Not Ever Never
Eat a Tomato* by Lauren Child, first published in the UK by Orchard Books, an
imprint of Hachette Children's Books, 388 Euston Road, London, NW1 3BH;
**50BL** The Double Fine Adventure logo is used with the permission of
Double Fine Productions; **50R** Swedish Hasbeens, spring/summer 2012;
**51** Courtesy Mondelez International; **52T** Courtesy Dragon Rouge and Danone;
**52B** Courtesy of IDEO. IDEO partnered with Firebelly Design, a local brand
strategy studio, to collaborate on a solution.; **53** Courtesy Noble Desserts
Holdings Limited; **54** Mood board: Tiziana Mangiapane. Images: Shutterstock.
com (clockwise from top left: Songquan Deng, Stock Creative, symbiot, Xavier
Fargas, Cora Mueller, Legend_tp, Imfoto); **55TL** iStock © maybefalse;
**55TR** The shown design is owned by Crabtree & Evelyn and is protected by
Crabtree & Evelyn's trademark registrations. The modernized version of the
design is owned by Crabtree & Evelyn and is protected by Crabtree & Evelyn's
trademark and copyright registrations.; **55CR** © Clynt Garnham Publishing /
Alamy; **55BCR** Courtesy Agent Provocateur; **55BR** IBM; **57TL** JuliusKielaitis /
Shutterstock.com; **57TR** Courtesy Dragon Rouge and Newburn Bakehouse;
**57B** Courtesy Harvey Nichols; **59L** Courtesy Britvic Soft Drinks; **59R** Vanish
is a Reckitt Benkiser (RB) global brand; **61** Courtesy Pret A Manger, Europe, Ltd.;
**63** Bluemarlin Brand Design; **64** Image Courtesy of The Advertising Archives;
**65** Jon Le-Bon / Shutterstock.com; **66L** ©1000 Extra Ordinary Colors, Taschen
2000. Photo by Stefano Beggiato/ColorsMagazine; **66R** © Todd Gipstein/Corbis;
**69** Johnson Banks; **70** Bluemarlin Brand Design; **72** Courtesy Hello Monday

(Art Directors: Sebastian Gram and Jeppe Aaen); **75T** Courtesy Pentagram.
Pentagram designed the new identity, which established a system for the
consistent treatment of images and type (Paula Scher, Partner-in-Charge;
Lisa Kitschenberg, Designer). All pictured examples of the new identity were
designed by Julia Hoffmann, Creative Director for Graphics and Advertising at
the Museum of Modern Art, and her in-house team of designers.; **75B** Johnson
Banks; **76** Courtesy Gist Brands; **77** Johnson Banks; **78L** Courtesy Dragon
Rouge and Hero Group; **78R** Pope Wainwright; **79TL** Bluemarlin Brand Design;
**79BL** Courtesy Dragon Rouge and Hero Group; **79TR**, **BR** Courtesy of IDEO.
IDEO partnered with Firebelly Design, a local brand strategy studio, to
collaborate on a solution.; **80TL** Courtesy of IDEO. IDEO partnered with
Firebelly Design, a local brand strategy studio, to collaborate on a solution.;
**80BL** Courtesy Duffy & Partners LLC. Branding & Design: Joe Duffy, Creative
Director; Joseph Duffy IV, Designer; **80R** David Airey; **81TL** ©Glenn Wolk/
glennwolkdesign.com; **81BL** Courtesy of IDEO. IDEO partnered with Firebelly
Design, a local brand strategy studio, to collaborate on a solution.;
**82R** Bluemarlin Brand Design; **82TL** Art Direction : Edwin Santamaria. Design
for : OSG a VML Brand.www.elxanto3.co; **82BL** Cathy Yeulet / Shutterstock.com;
**83L** Ameeta Shaw, Freelance Graphic Designer; **83R** baranq / Shutterstock.com;
**84** Imagelibrary/272, LSE collections; **85R** Damien Newman, Central Office of
Design; **88** © JPM/Corbis; **91T** Cathy Yeulet / Shutterstock.com;
**91B** © SurveyMonkey; **94T** ©2012 AutoPacific New Vehicle Satisfaction Survey;
**96** Bluemarlin Brand Design; **97** Courtesy Sarah Bork, Janita van Dijk, Sandra
Cecet, Morten Gray Jensen, Basil Vereecke, TU Delft (Industrial Design
Engineering). Method developed by David and Dunn (2002); **98** Courtesy
Runtime Collective Limited, trading as Brandwatch; **99** Courtesy howies /
howies.co.uk; **100** Quigley Simpson; **101** Courtesy Dragon Rouge and Newburn
Bakehouse; **102** Tiziana Mangiapane; **105** © Labbrand, a leading China-
originated global brand consultancy. Other copyright holders: Charlotte Zhang,
Ryan Wang, Rachel Li; **107** ygraph.com / Source: BizStrategies; **108** © Matthias
Ritzmann/Corbis; **110L** Courtesy Tesco; **110CL** Courtesy Tesco; **110CR** iStock ©
Oktay Ortakcioglu; **110C** Courtesy Coldpress Foods Ltd.; **111T** Radu Bercan /
Shutterstock.com; **111C** iStock © ewastudio; **111B** Photos courtesy Roundy's Inc.;
**112L** Courtesy ibis budget; **112C** Image courtesy Royal College of Surgeons of
Edinburgh. Design by Emma Quinn Design (original was); Philip Sisters (circle,
wording and strapline); **112R** constructlondon.com, Creative director: Georgia
Fendley, Design Director: Segolene Htter, Design Director: Daniel Lock;
**113** Bluemarlin Brand Design; **114** Bluemarlin Brand Design; **116** Bluemarlin
Brand Design; **119** Branding: Kokoro & Moi; Interior Design: Koko 3; **120** The
Future Laboratory; **121** Courtesy Dragon Rouge and Newburn Bakehouse;
**124** Tiziana Mangiapane; **126** Courtesy of IDEO; **128** Hannah Dollery, Good
Design Makes Me Happy; **129** © Johnny Hardstaff; **130T** Kane O'Flackerty;
**130B** Bluemarlin Brand Design; **131L** © Sara Zancotti. Model: Geoffrey Lerus;
**131R** iStock © Lorraine Boogich; **133** Images Courtesy of The Advertising
Archives; **134** Courtesy Dragon Rouge and Danone; **135** Brian Yerkes, Brian
Joseph Studios; **136** Kane O'Flackerty; **137T** Kane O'Flackerty; **137C** Kane
O'Flackerty; **137B** Simon Barber; **138** Simon Barber); **140** Courtesy Duffy &
Partners LLC. Branding & Design: Joe Duffy, Creative Director; Joseph Duffy IV,
Designer; **142** Courtesy Dragon Rouge and Newburn Bakehouse; **143** Courtesy
Dragon Rouge and Hero Group; **144T** Olly Wilkins; **144B** Moving Brands;
**145** Bluemarlin Brand Design; **147T** Dr Neil Roodyn, nsquared solutions;
**147C** Bluemarlin Brand Design; **147B** Heidi Kuusela; **148** Moving Brands;
**149** Moving Brands; **150** Spiral Communications (Leeds) spiralcom.co.uk;
**154** Courtesy Duffy & Partners LLC. Branding & Design: Joe Duffy, Creative
Director; Joseph Duffy IV.